Fearless
Watercolor
for beginners

ADVENTUROUS PAINTING TECHNIQUES TO GET YOU STARTED

SANDRINE PELISSIER

NORTH LIGHT BOOKS
CINCINNATI, OHIO
www.ArtistsNetwork.com

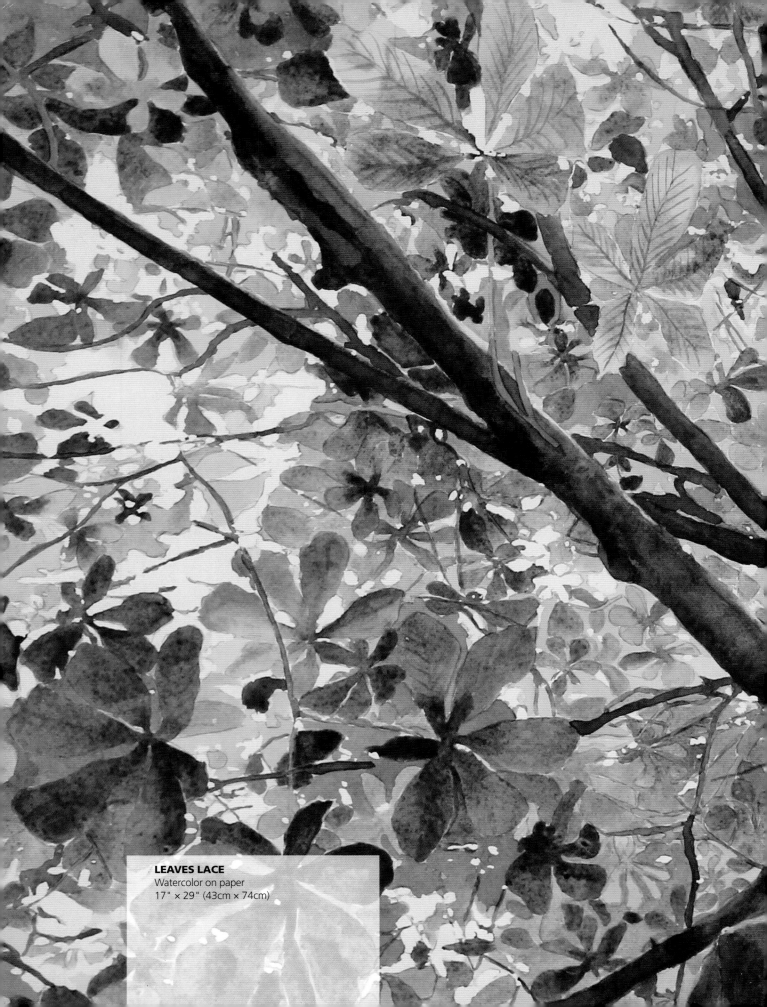

LEAVES LACE
Watercolor on paper
17" × 29" (43cm × 74cm)

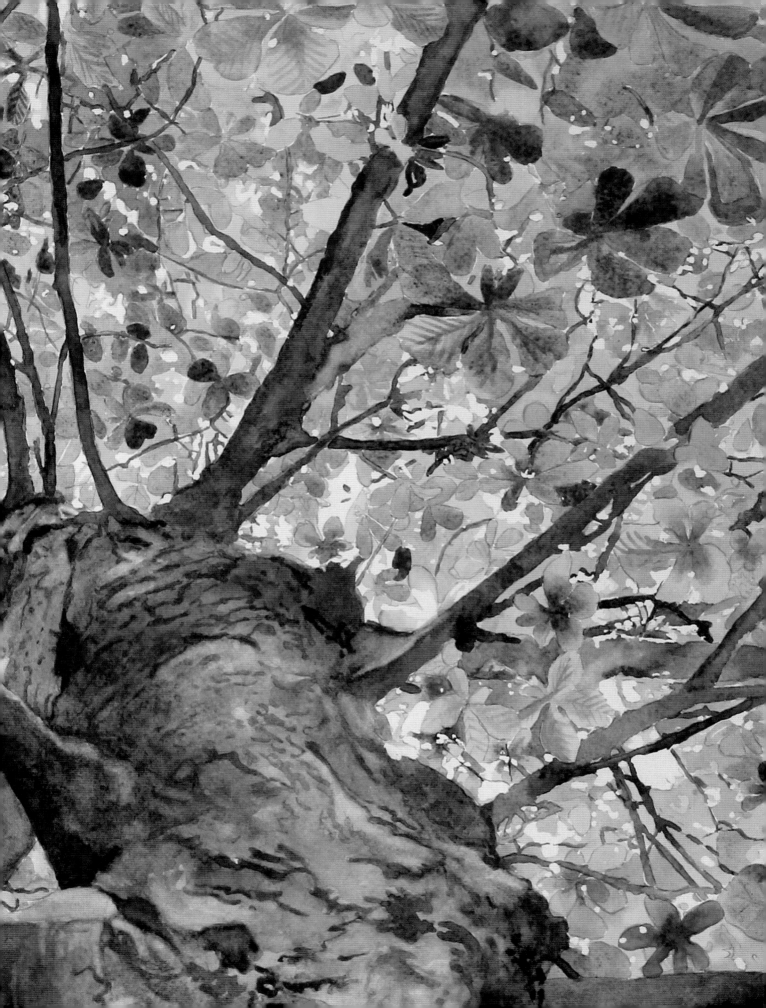

CONTENTS

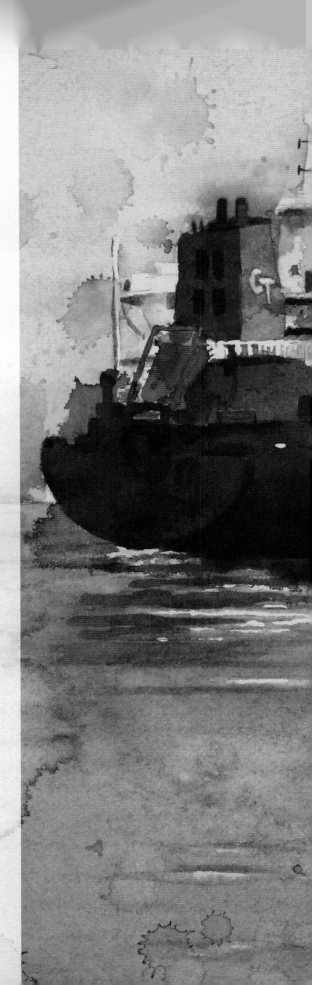

CHAPTER 1
Before You Start 8

It's All About the Water • The Importance of Taking Risks, Making Mistakes and Having Fun • About Style and a Place and Time to Paint • Documenting Your Process • Planning and Improvising

CHAPTER 2
What You Will Need 20

Different Kinds of Papers and How They Affect Your Painting • The Star: Paint Tubes and Pans • Brushes and Alternatives • Other Materials • Transferring Your Drawing

CHAPTER 3
Basic Techniques 38

Washes: The Basis of Watercolor Painting • Graded Washes • Variegated Washes • Properties of Your Pigments • Mixing Colors • The Basics of Color Theory • Mixing Colors on Paper • Layering Colors • Painting with Multiple Color Mixing Techniques • The Importance of Edges

CHAPTER 4
Techniques for Adding Texture 80

Splatters, Drips and Drops • Salt Textures • How to Paint with a Dry Brush • Cutout Wax-Paper Shapes • Alcohol and Water Textures • Scratching Off Paint • Wax Resist • Back Runs • Plastic Wrap • Soap

CHAPTER 5
Incorporating Mixed Media 104

Breaking the Rules and Having Fun • Mixing Dry or Oil Pastels with Watercolor • Adding Gouache to a Watercolor Painting • Adding Acrylic Paint • Adding Colored Pencil • Drawing with Watercolor Pencils • Sewing on Paper • Adding Zentangles® with Markers • Combining Painting and Drawing • Drawing with Watercolor Pencils and Pastels • Mixed Media on Yupo Paper • Effects on Yupo Paper

CHAPTER 6
A Few Last Thoughts 134

Be Your Own Critic • Criteria for Evaluation • Finishing

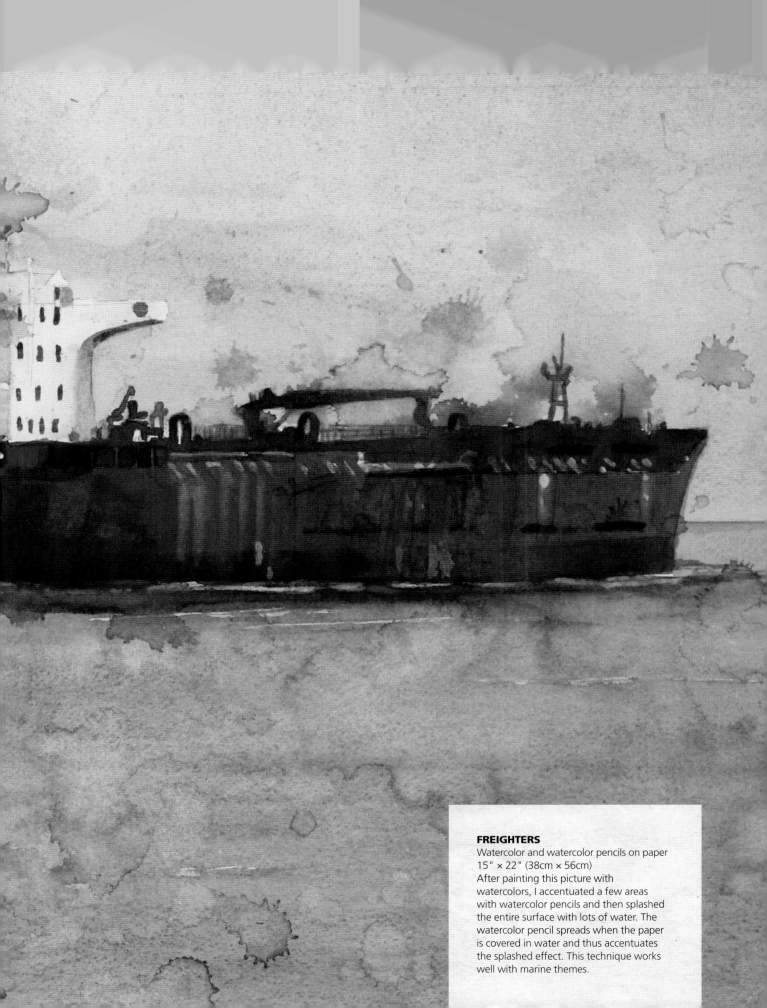

FREIGHTERS
Watercolor and watercolor pencils on paper
15" × 22" (38cm × 56cm)
After painting this picture with
watercolors, I accentuated a few areas
with watercolor pencils and then splashed
the entire surface with lots of water. The
watercolor pencil spreads when the paper
is covered in water and thus accentuates
the splashed effect. This technique works
well with marine themes.

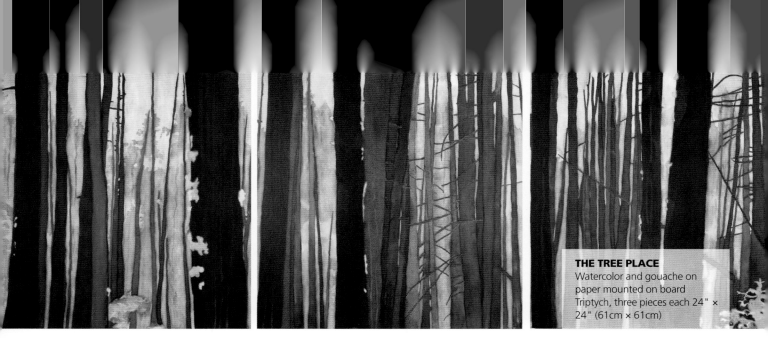

INTRODUCTION

The first time you painted with watercolors, you might have been surprised by this medium, which seems to have a life and mind of its own, as the paint swiftly moves across the paper.

It is also translucent, which means marks are not easily covered. Watercolor can feel like an unpredictable and unforgiving medium at first.

This is what makes watercolor both challenging and exciting. With experience and the right tools you will learn how to gain some control over the paint, be able to predict how the pigments will behave, master different techniques and learn how to fix mistakes. Even though an element of chance will always be part of the appeal, you can enjoy a fearless and relaxed approach to watercolor painting.

Watercolor is a very versatile medium that can look quite traditional or contemporary and is suited to a variety of styles from photorealism to abstract, from low contrast to very high contrast, from precise to loose.

It can be painted in a traditional transparent way on paper or it can be mixed with other media and painted on a variety of supports: Yupo paper, canvas, paper prepared with medium or gesso, paper mounted on board, and more.

This book will give you an overview of some of the many possibilities watercolor painting offers. You will learn a series of basic skills that will give you the knowledge

you need to get started. The book consists of three main parts:

- before you paint (preparation, planning and materials)
- when you paint (techniques)
- after you paint (assessment and finishing)

For some techniques there are a variety of ways to achieve the desired result. I don't believe there is just one way or one technique that will work for everyone. I would like you to choose what you think will work for your particular style or taste, and leave behind what won't work for you.

Each new technique is illustrated with a step-by-step demo, and some include links to online videos that show how to apply that technique to a specific painting or that share exercises to help you practice.

You will learn about preparation, materials and various techniques: washes, painting wet on wet and wet on dry, blending or layering colors, preserving the white of your paper, lifting color, achieving a variety of edge qualities, adding textures to your paintings and fixing mistakes.

We will also discuss how to plan out your painting (one of the keys to growing confidence and avoiding confusion while painting), how to assess your own work and what finishes you can apply.

MATERIALS USED IN THIS BOOK

Don't feel like you need to have all of these products in order to start painting and creating. Begin with the techniques and exercises that require materials you already have or the basic necessities: watercolor paints, paper and brushes. Then, as you progress through the book, add a few new mediums and materials as they strike your fancy. Pretty soon you will know what suits you and where your passions lie, and you'll have the tools and materials you need to follow your painting dreams.

Paper: 90-, 140- or 300-lb. (190gsm, 300gsm or 640gsm) hot-pressed, cold-pressed or rough, prestretched or unstretched; Yupo paper

Watercolor paint: pans or tubes in your choice of colors (should include at least six "primaries")

Palette: watercolor, ceramic or butcher's tray

Brushes: of your choice (rounds and flats in sizes 1, 10 and 20 and a few mop or hake brushes are good to start)

Other basic tools and materials: brayer, sponges, droppers, spray bottle, hair dryer, masking fluid and silicone brush, ruler, scissors, craft knife, tissues, cups or glasses for water, small bowls, fixative, varnish, wax medium, gel medium

For stretching paper: board or foamcore, tub of water, stapler or tape, paper stretcher

For image transfer: pencils, pens, graphite or carbon paper, projector, light box, storage box, linkable fluorescent lights, box cutter, extension cord, Plexiglas

Materials for adding texture: soap, granulation medium, alcohol (isopropyl or rubbing), acetone, bleach, lemon juice, gouache, salt, rice, shapes cut from wax paper, thread, wax crayons, plastic wrap, toothbrush, hair brush, small stiff-bristled brush, tools for scratching such as painting knives and plastic cards

Mixed media: oil pastels, chalk pastels, ink, India ink, acrylic paint, colored pencils, watercolor pencils and crayons, markers, ink pens, pencils, graphite, tissue paper, collage paper, sewing machine, needles, thread

CLICK IT! WATCH IT! DOWNLOAD IT!
You will find icons and directives similar to these throughout the book. They are your key to unlocking terrific FREE bonus content, content that includes downloadable PDFs, video demonstrations and tips from the author. All bonus content is linked through **ArtistsNetwork. com/fearless-watercolor**. Be sure to stop by and take advantage of ALL that **Fearless Watercolor for Beginners** has to offer!

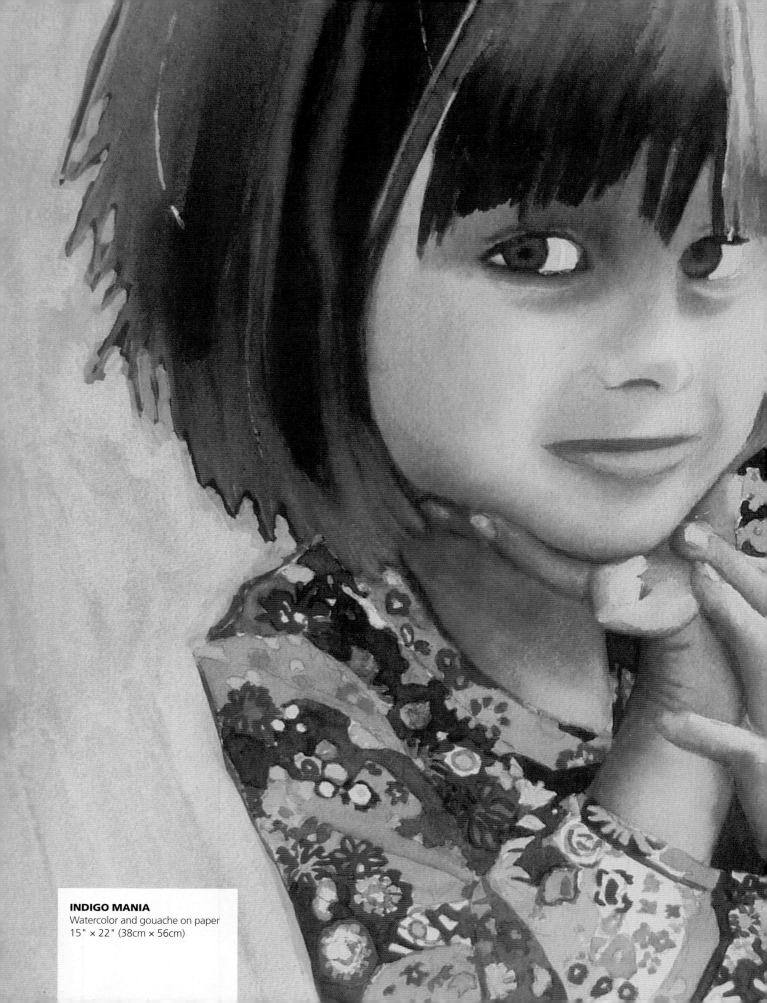

INDIGO MANIA
Watercolor and gouache on paper
15" × 22" (38cm × 56cm)

Before You Start

PELISSIER

IT'S ALL ABOUT THE WATER

Water is always the most important factor in determining how watercolor paint will behave. The ratio of pigment to water influences how dark your wash will be. The wetness of your paper influences the speed at which the paint will move on the paper and the hardness or softness of your edges. Paying attention to and learning to control how much water goes in your wash mix, on your brush and on your paper gives you more control over the watercolor medium.

But First, Let's Take a Step Back. What Exactly is Watercolor?

Watercolor is basically pigment in a water-soluble binder. The water-soluble binder allows the pigment to be spread with a brush. It also aids the pigment in binding to the paper once dried.

A few additives (like plasticizer, humectant, filler and dispersant) are mixed with the paint to increase its shelf life and modify some physical properties.

Traditionally the binder is gum Arabic but in some modern brands the binder may be synthetic.

Water and pigments sometimes move in the same direction, sometimes in opposite directions, because of the different forces that move them:

- Paint pigments move from more to less concentrated areas. This is called diffusion.
- Water moves from the wettest to driest area.

Other factors can influence the movement of the paint, including the sizing, texture and tension of the paper.

The size of the microscopic particles that comprise a paint's pigment also plays a role in how the paint behaves on paper. For example, a color wash mix made with a color comprised of bigger pigment particles will separate after a few minutes; the pigments will sink to the bottom of your surface (into the textured parts of the paper or the crevices). Meanwhile a wash mix made with a color comprised of very small particles will

Watercolor is a fun, affordable, odorless and easily transportable medium.

stay perfectly mixed indefinitely. Another way to think about it: Granulating colors are made of bigger pigment particles and the granulation occurs when these particles sink into the tiny crevices of the paper.

Sometimes when a color is made of a mix of large and small pigments suspended in water, the larger pigment particles (which are often also the darkest pigments) will sink first into the palette or well. Therefore, if you don't stir up your paint first, you might see a lighter layer of color (made of smaller pigments particles) settle on top.

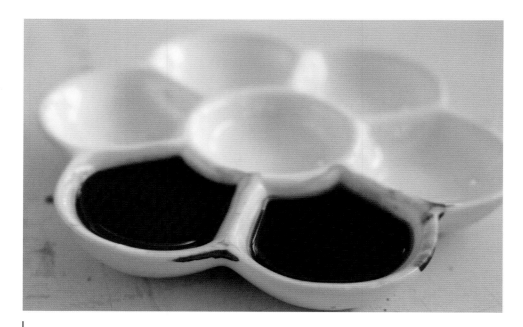

The same mix of Cobalt Blue and Burnt Sienna looks different in the two wells. The one on the left has just been mixed, and the one on the right was untouched for about ten minutes. When painting with a wash, it is always a good idea to stir it with a brush before painting if you want a homogenous color.

Does All That Stuff About What Paint is and How It is Made Really Matter?

There is no need for you to understand all the chemistry behind paint behavior. Painting regularly will give you an intuitive sense of how the paint will behave and how much water and pigment you will need to use for the desired effect. With time you will learn which techniques fit your painting style the best.

You'll also figure out which colors and color mixes you enjoy using the most. Just remember to pay attention to how much water goes on your brush, your paper and into your color mix, as that is the most important factor in painting with watercolor.

Watercolor Dries Lighter

Watercolor color always dries a bit lighter than it appears when wet—approximately 20 percent lighter. Another factor to consider: It is always easier to add an extra layer to darken an area than to remove paint to lighten an area. If you are in doubt, remember that you can always go a bit lighter and layer additional washes. Just make sure one layer has dried completely before adding the next.

 If your painting doesn't take the entire surface of your paper, you can use white space to try out colors before painting. Allow these tests to dry to see what to expect. You can also keep pieces of leftover paper to try out colors and mixes, saving them for posterity.

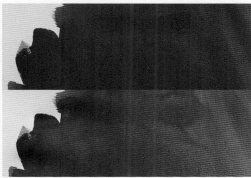

Wet Permanent Red wash

Dry Permanent Red wash

Watercolor, when dried, will appear to be a bit lighter and duller than when it is wet. With time you will be able to approximate that effect and compensate for it by painting your washes a bit darker.

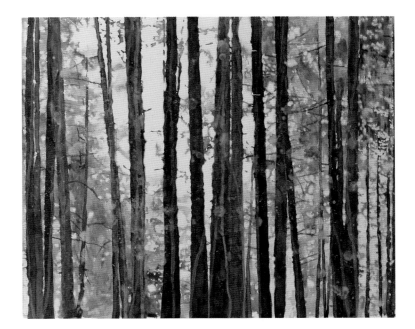

HIKING WITH THE DOGS
Watercolor and gouache on paper mounted on board
20" × 24" (51cm × 61cm)
Hiking with the Dogs was first painted using a wet-on-wet technique for the foliage and a layering technique for the trunks. To create a more watery effect, I decided to add drops of blue paint and splashes of water. I also let some of the paint drip. This is a somewhat risky technique because it could have ruined the painting. But because I knew from experience how the paint would behave, I decided to take that risk.

THE IMPORTANCE OF TAKING RISKS, MAKING MISTAKES AND HAVING FUN

When you think about it, it has happened to every artist, even the most talented ones: We all, at one time or another, find ourselves unsatisfied with our creations. After all, creating is very much a process of trial and error. When you experiment and take risks, you learn and grow. Stop experimenting and taking risks and you might just find that you have also stopped *learning*. Mistakes can (and should) be viewed as the by-product of the learning process; a lack of mistakes might be a sign that you've lost a certain enthusiasm that comes with taking risks.

Don't be discouraged by any unsuccessful attempts at watercolor. They are a necessary step in preparing for your next successful painting, and they are a sure sign that you are learning and taking risks.

Furthermore, it is my belief that creative energy sometimes shows in a painting even though technique (or other factors) might not be perfect. That energy can make a painting very interesting. You can also sometimes feel the lack of energy when the artist is halfheartedly applying his or her efforts or just making a piece to sell.

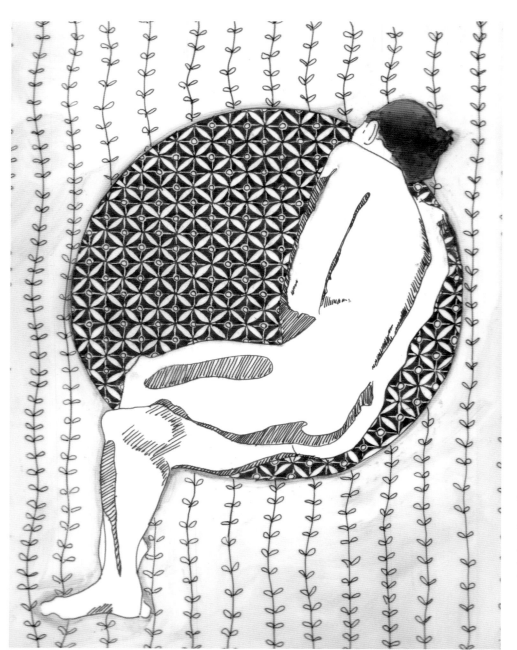

LIFE PATTERNS #2
Watercolor and mixed media on Yupo paper
12 " × 9" (30cm × 23cm)
I wasn't sure at first how I could make it work, but I knew I wanted to try combining the spontaneity of my life drawings with the regularity of Zentangle®-like patterns. This kind of work is a bit different from what I usually do, but I enjoyed taking the risk of trying something that was new to me.

Is Watercolor a Difficult Medium? I've Heard Watercolor is a Difficult Medium.

It can be intimidating to take on a new medium, especially one with as contentious a reputation as watercolor. Watercolor is commonly thought to be very difficult, unforgiving and technical, but it is actually a much more forgiving medium than you might think.

Watercolor offers many advantages; it is odorless, affordable and easily transported. It is a versatile medium that can be used to paint in many styles, from hyperrealistic to abstract. Long gone are the days when watercolor was synonymous with pretty pictures featuring washed-out colors. Today watercolor can be used in very contemporary paintings, by itself or in mixed-media pieces. (You can read more on mixed media in *Chapter 5: Incorporating Mixed Media.*)

But I've Tried It Before and I Don't Like My Paintings.

Perhaps you don't like your paintings *yet*. Painting can become stressful if too much emphasis is put on the outcome. As with any other activity, you will come closer to your goals when you invest the time to practice regularly—ideally a bit every day. Becoming a proficient watercolorist will take some time but that doesn't mean you can't enjoy painting and the results of your painting in the meantime.

Sometimes thinking more about enjoying the process of painting itself can make painting more joyful. Even if a painting does end up in the garbage, that doesn't mean you've wasted your time. Maybe there's a lesson here; perhaps you have learned what not to do.

Before You Throw That Painting Out

We tend to be much more critical of a painting just after it's been finished, perhaps because we are so focused on evaluating the painting and fixing mistakes in the last stages of the process. Sometimes all that's needed is a bit of distance to regain an objective point of view. Try this: The next time you finish a painting, put it away and leave it alone for a few days, or a few weeks, whatever is comfortable for you. Then re-examine it with fresh eyes. You might discover that it wasn't so bad after all. In *Chapter 6: A Few Last Thoughts*, we will discuss several strategies you can use to evaluate your own work objectively.

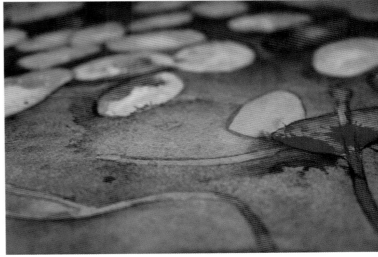

LILY PADS ON ONE MILE LAKE (DETAIL)
Watercolor on paper, mounted on board and varnished
12" × 36" (30cm × 91cm)

Perfection is Overrated

Your artwork doesn't have to look perfect all the time; a bit of messiness can add interest. Having fun is the key. All the time. Enjoying the painting process will make you want to spend more time painting. Enjoying the process will keep you motivated and help you build your skills.

The things that help you relax and enjoy the process will be different for everyone. I personally enjoy drinking a cup of tea and listening to French radio when painting. It helps me get in the zone.

DOWNLOAD IT! Visit **ArtistsNetwork .com/fearless-watercolor** for a downloadable PDF: **Fixing Mistakes and Lifting Color**. Sandrine shares techniques for fixing what you might not like in your work.

ABOUT STYLE AND A PLACE AND TIME TO PAINT

Help! I Don't Know What My Style Is. I'm Not Even Sure I Have One!

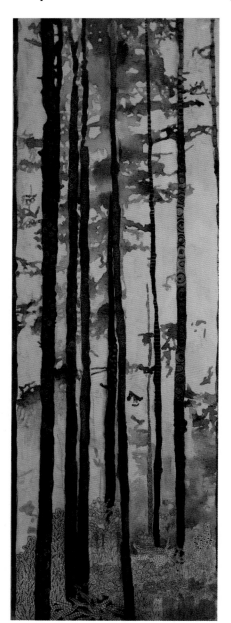

FOREST QUILT
Watercolor and mixed media on canvas
36" × 12" (91cm × 30cm)
I had for quite some time an interest in patterns that I kept separate from my paintings, but this interest is now showing up more in my work. In this forest landscape, for example, I incorporated repetitive patterns in the tree trunks and painted the foliage in a more traditional way with watercolors mixing wet on wet.

As an emerging or professional artist there is considerable pressure to come up with a unique style and to stick to it so that it becomes recognizable, your hallmark. Ideally a body of work should be very consistent in style, size, medium and subject. Or so "they" say.

Of course, developing your own distinctive style can be a good thing, as long as there is still room to improve and evolve as an artist. But this is absolutely not something to worry about when learning a new medium. This is a time to learn and experiment. Feel free to explore any subject and experiment with styles and techniques to your heart's content. Your own personal style will develop naturally, because you will be repeatedly drawn to what you like and perhaps also by the feedback you get when you share your paintings.

Deciding to act on that feedback (or not) is a personal decision, but here are a few things to think about on that subject:

- If all artists try to please the maximum number of viewers, then we might all end up doing mainstream, predictable art. But art can—and should—be used to move people out of their comfort zones.
- No artist is universally loved and admired. It's an exercise in futility to think you can make everyone a fan.
- We all paint for different reasons; sometimes we paint for ourselves (perhaps painting helps us deal with personal issues, for example). Sometimes we paint for the viewer, like when we desire to share the beauty of our subject with an audience. The point? Feedback might matter less if the purpose of painting is more personal.
- Every artist has funny stories about unbelievable comments people have made about their art. The truth is that someone will always find something unpleasant to say. You don't have to listen if you don't want to. At least you had the courage to publicly share something you created.
- The most important person to please with your art is yourself.

A Painting is a Cascade of Decisions

The process of painting from start to finish can be seen as a cascade of decisions that is begun when you choose your subject, medium, substrate and size. When you are painting, you are deciding on color, placement and technique. This cascade of decisions ends only when you decide that the painting is finished. No two people are likely to make the exact same decisions from start to finish. The act of making these decisions sets you apart from everyone else and begins the process of defining your own personal style.

Do I Need a Studio to Paint?

Watercolor is not a medium that requires a very complicated setup, but if you can dedicate a place to painting, that is ideal. A dedicated studio space is preferred, but all you really need is a place dedicated to painting, even if it is just a small table in a room in your home. A space that is comfortable for you. After all, the French painter Pierre Bonnard executed lots of his paintings in his home's bathroom because he liked the light there.

Another reason to have a dedicated space: Not having to put everything away and take it out every time you paint saves precious time and energy and helps you stay motivated.

A painting studio is ideal, but starting with a small dedicated area of your home will also work.

How Much Time Should I Dedicate to Painting?

Setting up a regular time to paint is helpful, especially if you are working from home, because it is easy to get distracted by the million other things you have to do. Deciding that certain hours and certain days will be your painting time will help build a habit. Then you just have to work on eliminating (or ignoring) distractions like the computer, the phone and social media during your painting time.

How much time to dedicate to painting depends, of course, on the time you have available. But the more often you paint, the faster you will see improvements. I started to see a difference in my skills as soon as I started painting a bit every weekday.

Commit to this time. Make it clear to family and friends that you should not be disturbed during your painting time, that you won't answer the phone, go for coffee, walk the dog or cook dinner. No, it's not selfish. Sometimes you have to say no to preserve your precious painting time. You deserve to do something for yourself.

Success is 10 Percent Talent and 90 Percent Sweat

"She is so talented!" Even though everyone enjoys a compliment, I would rather focus on hard work and motivation than talent. I don't believe people who excel at something do so simply because they received a fairy's blessing in the crib. Hard work and an investment of time are usually integral. Of course some people do show a facility to learn particular skills while others might struggle. But I think the time and effort you are willing to dedicate to your specialty and the depth of your motivation matter more.

DOCUMENTING YOUR PROCESS

Taking Pictures Will Remind You of the Steps You Took While Painting.

I urge you to consider taking pictures of your painting process. Your photos will act as a visual journal, helping you remember what you did. It is also an interesting exercise to observe your process from an outside point of view. Once you are comfortable with your skill level, you might be interested in sharing your techniques with others, sharing pictures of your progress or sharing behind-the-scenes photos on social media.

Today's digital point-and-shoot cameras offer terrific quality and might be all you will need for documenting your process for yourself or a website or blog.

If you want to share pictures of your process on social media, a cell phone works well.

If you are taking pictures for publication or any kind of printed document, you might want to invest in a digital SLR that offers good resolution settings and options for taking pictures in RAW format. You will also need a lighting kit with two light stands (and fluorescent light bulbs) that you can place on either side of your work at 45° angles.

CLICK IT! Visit **ArtistsNetwork.com/ fearless-watercolor** for clickable links to great resources for photographing your art.

Cell Phone with Camera

Digital Point-and-Shoot Camera

Digital SLR Camera

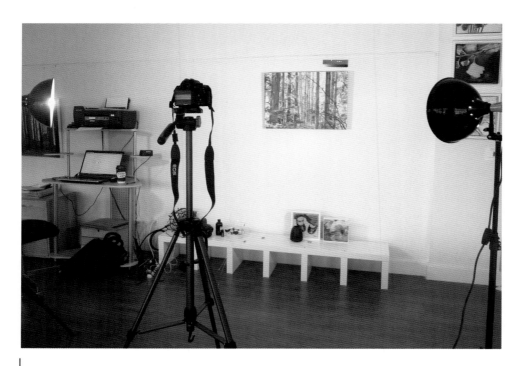

A Basic Photography Lighting Setup

Setting up two fluorescent lights at 45° angles to your painting will give you the best light for taking pictures.

Making a Video

You might be surprised by what you see if you record your painting process.

Taking videos is also a great way to see yourself work from a different perspective. You will need a video camera, a tripod, good lighting and video processing software. The software should allow for reframing, time-lapse photography, captions, titles and formatting.

Yes, seeing yourself painting in real time might be a bit boring, but a time-lapse video of yourself working is a fun and interesting experiment. It gives good insight into your working process because accelerating the frame rate removes much of the hesitation and "thinking" time. You see only the action and you get a better perspective of what you did from start to finish.

Filling Out a Form

Pictures and videos act as a kind of visual reminder of what you did. But it can also be interesting to take notes. Filling out a form for each painting project can help you remember details, like what colors you used and what type of paper. You can keep track of particular mixes of colors you like, how a paper reacted and what techniques you used. Sure, the details might be fresh as you are painting, but you will most likely forget them after a while. And they might come in handy if you have to write about a particular painting later on.

DOWNLOAD IT! Visit **ArtistsNetwork .com/fearless-watercolor** to download Sandrine's **Painting Project Details form**.

Writing a Blog

If you are comfortable with sharing your work or your process online, maintaining a blog is a fun way to keep an online art journal. You can share your techniques with step-by-step tutorials, speak about what inspires you and provide updates about your exhibitions or open studios.

CLICK IT! Visit Sandrine's blog: **PaintingDemos .com**.

Making Portfolios

Having a way to present your work to potential customers, galleries or visitors to an exhibition is always useful. I like to make handwritten portfolios with pictures of my paintings. I've noticed that visitors to my studio like to browse through them; it is also a nice way to get the conversation going. People will talk about what they like in your work, or sometimes they will mention they have seen a particular painting somewhere.

PLANNING AND IMPROVISING

Should I Plan My Painting or Can I Improvise?

It is a matter of personal choice.

Different kinds of painters with different painting styles will use different techniques. Some might prefer a bit of improvisation and can start painting without even a preliminary drawing. Others might feel better with a very detailed drawing, a clear idea of what they want the finished painting to look like and a list of steps they will take to get there.

Personally I enjoy painting more when I know roughly what result I am hoping for and how I will get to that result. But again, it is a matter of personal taste, and that doesn't mean that you can't change your mind along the way or try something you didn't plan for.

The Main Rule is There is No Rule

When tackling a new medium, the simplest and most natural way of learning is to try to reproduce the steps of someone more advanced in that domain. Copying is a valuable way of learning and many artists have spent time in museums, imitating works of the masters they admire. I also think that after a certain point—when you become more confident in your own skills—choosing your own path and making your own decisions is more valuable than copying. After all, what is working for one artist might not work for another. Bottom line: Don't be afraid to take risks and break the rules; you will be learning and certainly developing more of your own unique style that way.

What About Areas of White in My Painting?

When painting with watercolors in a traditional way, any white in the painting is the white of the paper or, more exactly, areas of the paper that have not been painted. So when planning a painting, I usually know from the start what areas will remain unpainted. If these areas are too small or too intricate to paint around, I will preserve them with masking fluid. If you are more of an impulsive painter and want to move toward improvisation, one thing to think about before starting to paint is white space. You must remember to either mask your white spaces or plan to paint around them. You could, if you prefer, add white areas and highlights with white gouache, acrylic paint or pastels later in the process. (More on that subject in *Chapter 5: Incorporating Mixed Media*.)

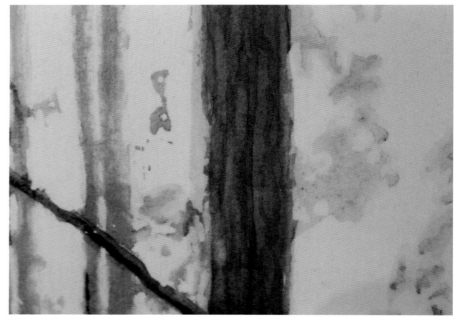

Planning for Areas of White
Before starting to paint this forest landscape, I had to know which areas would be left white, so I could preserve them with masking fluid.

How Much Can I Change My Mind?

Watercolor can be lifted off the paper to a certain point depending on the pigment's staining power. But it is always easier to darken an area than to lighten it, which is why most watercolorists paint from light to dark. Painting from light to dark will also help prevent darker colors from smudging into lighter colors. Working this way is not a guarantee for all techniques and all paintings, but it is a solid starting point.

If you are open to experimentation and incorporating mixed media into your work, you always have the option to paint over some areas with acrylic or pastels, or to add collage over previously painted areas. Being open to these techniques will allow you to change your mind quite a bit.

Removing Watercolor
Watercolor pigments can be moved around quite a bit. They can be lifted with a brush, tissue paper or an eraser. They can also be displaced with a stiff brush and water, or removed with a razor blade when dry.

Can I Mix a Bit of Planning with a Bit of Improvisation?

Of course you can! I've noticed that when I start a painting from a reference photo, I stay as close as possible to that reference in the early stages of the painting. I plan out the steps because it gives me a starting point. But as the painting progresses, I tend to distance myself from that reference. I look at the painting as something separate from the reference, something that might call for different choices. That is usually when the improvisation and experimentation join the game. I might feel more like taking risks and interpreting the subject as one of my own rather than being too dependent on realism.

You might discover that mixing a bit of planning with a bit of improvisation is a good prospect for you. You might also find that each painting is different, and some seem to paint themselves while others are a struggle from beginning to end. None of these things are predictive of how much you will like any painting at the end.

To Improvise or Not to Improvise
Splashing paint on a painting can add an element of improvisation and excitement to an otherwise planned-out process.

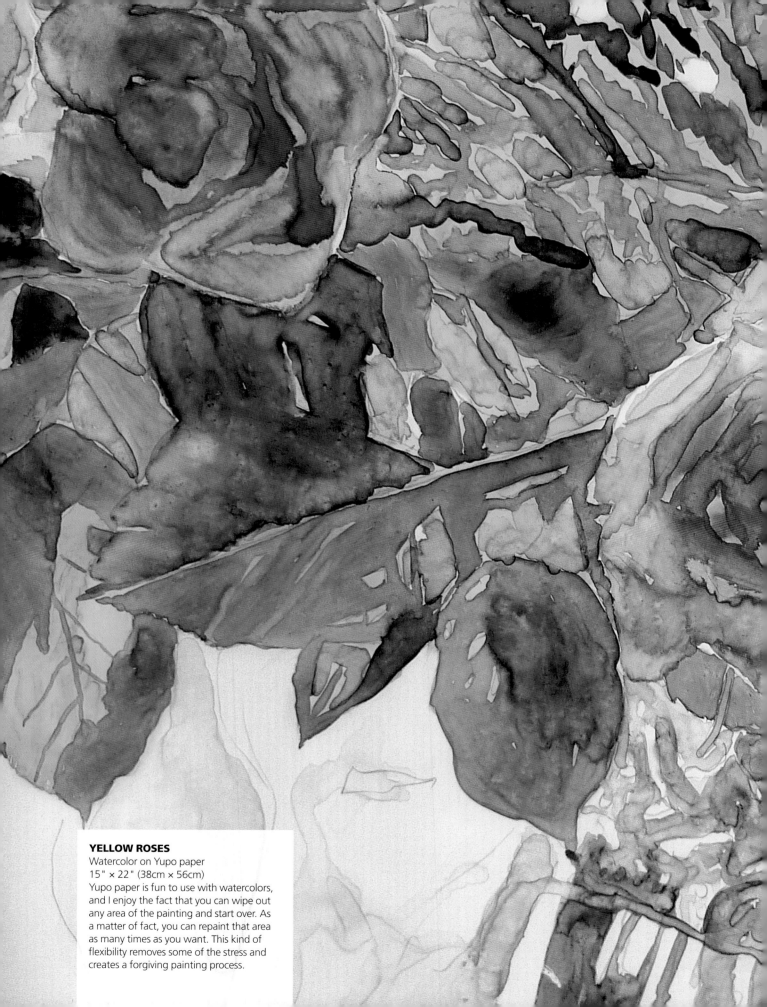

YELLOW ROSES
Watercolor on Yupo paper
15" × 22" (38cm × 56cm)
Yupo paper is fun to use with watercolors, and I enjoy the fact that you can wipe out any area of the painting and start over. As a matter of fact, you can repaint that area as many times as you want. This kind of flexibility removes some of the stress and creates a forgiving painting process.

What You Will Need

DIFFERENT KINDS OF PAPERS AND HOW THEY AFFECT YOUR PAINTING

Watercolor paper comes in different textures, weights, colors, sizes and qualities. You can buy it packaged in pads, blocks or individual sheets.

In pads, the sheets are glued together on one side, and you usually take off one sheet of paper before stretching and painting it.

Blocks of paper are glued on all four sides and are designed so you can paint directly on the pad, although doing so will be appropriate only if you use a light hand with the water. Block paper is not usually prestretched, so if you are going to be using lots of water, it might buckle.

Individual sheets are a good solution if you want larger paintings or if you would like to try different weights and textures before investing in a pad. You can divide individual sheets of paper into smaller pieces.

Paper Weight

The weight of the paper is related to its thickness. The number you see when buying paper, usually 90-, 140- or 300-lb. (190gsm, 300gsm or 640gsm), is the weight of five hundred sheets of 20" × 30" (51cm × 76cm) paper (also referred to as "Imperial size"). So the higher the number, the thicker (and heavier) the paper.

Any paper under 300-lb. (640gsm) will need to be stretched before painting, especially if you will use a lot of water. Otherwise the paper might buckle when you paint. Buckling will cause water and pigments to accumulate in the valleys of the paper, which will make it difficult to paint a flat even wash.

Depending on the techniques you like to use, you might require a thicker paper. A 90-lb. (190gsm) paper will be too thin, for example, if you do a lot of wet on wet or if you are lifting color with a stiff brush. (You might damage the paper.) A thicker paper is also a better choice if you intend to remove some of the paint with a razor blade.

Watermarks

Most paper brands will have a watermark on one corner of the paper. If you don't want the brand to show on your painting, try to look for it before determining your painting area.

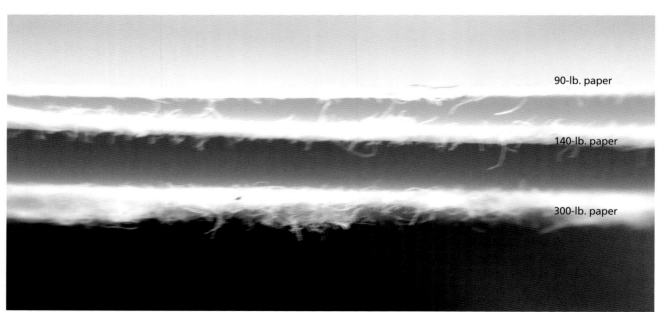

Side View of 90-, 140- and 300-lb. Paper
90-lb. (190gsm) paper feels like cardstock, while 300-lb. (640gsm) paper feels more like cardboard. 140-lb. (300gsm) paper feels in between and is the most commonly used weight.

90-lb. paper

140-lb. paper

300-lb. paper

Paper Textures

Paper comes in three textures: rough, cold-pressed and hot-pressed. The different textures are obtained during the manufacturing process. Depending on the brand you buy, you might see quite a bit of variation in the texture, as a hot-pressed paper from one brand might look more like a cold-pressed paper from another brand.

Rough

This is usually the most absorbent kind of paper. It is made without pressing, so the texture you see is a result of the irregularities in the pulp, and it is the most textured paper you can choose. Rough paper will emphasize any granulation in watercolor washes, and it will be easier to paint textures with a dry brush on this paper since the paint will cling to the peaks of the paper. It might be more difficult, though, to paint details on this kind of paper because of the rough texture. Another thing to consider: Paint won't be easily lifted from rough paper.

Cold-Pressed

Cold-pressed paper is a lightly textured paper and the most commonly used by watercolorists. It is more manageable than rough paper (which shows a bit too much texture for many watercolorists) and hot-pressed paper (which is much more smooth, allowing the paint to move very fast—perhaps too fast).

Paint pigments will accumulate in the valleys of cold-pressed paper, but you will be able to both lift up the paint and render fine details. It's a good compromise, as you get a bit of texture with cold-pressed but not so much that it makes painting details difficult.

Hot-Pressed

The texture of hot-pressed paper is very smooth. In fact, little to no texture is visible. This kind of paper will allow for the rendering of the finest of details. It will also be easier to lift color as pigments sit on the surface of the paper and not in the valleys. Colors will appear brighter than on the other kinds of paper. But because there are less obstacles, water and pigments will move faster, making the paint more difficult to control. You will also be more likely to see irregularities developing in your washes, like blooms, which can add a really nice effect to your paintings if you choose to embrace them.

Paint on Rough Paper
I painted a mix of Ultramarine Blue and Burnt Sienna on rough paper; you can see the heavier pigments of the Ultramarine Blue paint falling into the valleys of the paper.

Paint on Cold-Pressed Paper
This is the same watercolor mix painted on cold-pressed paper. The paper shows a bit of texture and the colors look flatter.

Paint on Hot-Pressed Paper
You will see that depending on the brands of paper you buy, there will be a bit of variation in textures. This hot-pressed paper, for example, has a bit of texture while others are totally smooth.

A Word About Yupo Paper

Yupo paper is not technically a paper as it is not made from wood. It is made from polypropylene, which is a plastic. Yupo paper is waterproof, very resistant to damage (almost impossible to tear) and its surface is totally smooth. These properties influence the way watercolor behaves when applied to it.

A combination of evaporation and absorption dries paint on regular paper. On Yupo paper the paint dries as a result of evaporation only. The consequence is that the paint will take more time to dry and will almost always produce textures while it dries.

As there is no grain on Yupo paper, all the pigments remain on the surface, so colors are brighter. You can also easily remove paint with a bit of water and a tissue, soft cloth or cotton swab. The paper will return to its natural white color unless your pigments are particularly staining. This is a welcome element for many watercolor painters since it means they can paint over an area as many times as they wish, until they are satisfied with the result.

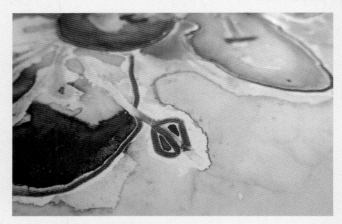

Paint on Yupo Paper
You can see the interesting textures the paint makes as it dries on Yupo. Some of the paint has been repelled along the pink line, which is a pink wax-crayon resist.

Paper Color

Watercolor paper usually comes in natural and bright white colors. Colors will appear more vivid on a bright white paper and more natural on natural white paper.

Yupo paper comes in white and translucent pads and individual sheets. Translucent paper can produce beautiful effects; you can paint or draw on both sides of the paper.

How Do I Choose a Paper to Paint On?

It depends on the results you wish to achieve and what is most important to you. Do you want to have control of the paint and render details? Or do you want to paint in a loose style and maybe have some happy accidents?

- Cold-pressed paper is the most commonly used paper. It offers a compromise between the smoothness of hot-pressed paper and the much more textured surface of rough paper.

- If you are looking for granulation, the paper needs to have texture so the paint particles can fall in the tiny crevices of the paper. Rough or cold-pressed will work.

- If you like brighter colors and a wet wash of fast-moving paint, choose hot-pressed or Yupo paper.

- If you like more texture, happy accidents and a looser style, go with Yupo paper or hot-pressed paper. The paint will be more difficult to control, making it easier to paint in a loose style.

- Rough paper is good if you want to loosen up, as the heavy texture makes it difficult to render details.

- If you want a detailed painting, hot-pressed is the way to go; the smooth surface will show more of the brushstrokes.

- Finally, if you want stress-free fun, Yupo might be the one to try; you will be able to repaint any area as many times as you need to.

Stretching Watercolor Paper

Because paper will buckle if its weight is less than 300-lb. (640gsm), whenever you expect to use lots of water or to paint large washes, you should stretch your paper before painting. You can use a wooden paper stretcher specifically designed to hold paper tautly in place, or you can use a board. When using a board you will need to tape or staple the paper to the board. I prefer foamcore. It is very lightweight and can be reused many times. I've never had too much luck with tape, so I prefer staples. Some artists use tape or a combination of staples and tape.

Many other surfaces are suitable to use as well. The only requirement is that the surface must be soft enough that you can staple the paper to it, and it must be acid-free to preserve the archival qualities of your paper.

1 Soak the Paper

Clean your hands before handling the paper; you want to minimize the oil transferring from your fingertips to the paper. Soak your watercolor paper in cold water for 5–10 minutes in a clean bathtub. Watercolor paper is covered with sizing, a substance that reduces the paper's absorbency. The sizing prevents paint from soaking into the paper too quickly. I suggest using cold water because warm water will remove too much of the sizing.

2 Test the Paper

To determine whether your paper has soaked in the water long enough, fold one of the corners. If the corner holds the fold, your paper is ready to be stretched. If the corner returns to its original position, the paper hasn't been in the water long enough. If the corner falls forward onto the paper, the paper has soaked for too long. You can still stretch the paper, but you might have lost some of the sizing; your paper, while still usable, may be more absorbent.

3 Stretch the Paper

When your paper is ready, take it out of the bathtub, holding it by two corners. Lay it flat on a piece of foamboard. Stretch it a bit and remove excess water with the palm of your hand.

4 Staple the Paper to the Board

Using a stapler that can be opened completely, staple the paper to the board, starting from the center of each side and moving toward the corners. Add a staple every few inches.

5 Let Dry

Lay the board in a flat position to dry. The water should be distributed evenly on the paper. The paper should be ready to use after a few hours, but allowing it to dry overnight is ideal. Stretching your paper will decrease the surface you can use for painting, as you will need to leave the stapled areas unpainted.

CLICK IT! Did your paper buckle? All hope is not lost. Visit **ArtistsNetwork .com/fearless-watercolor** for tips.

THE STAR: PAINT TUBES AND PANS

Watercolor paint comes in pans and tubes. Both forms have advantages and disadvantages.

Watercolor Pans

What are the advantages and disadvantages of watercolor paints in pans?

- Pan sets are easy to carry with you and make plein air painting a breeze.
- Pans are affordable: If you are a beginner and not sure what to buy first, a set of pans will get you started.
- You won't waste much color since you can use the paint in a pan until it is empty.
- You can usually buy individual pans to replace those you use up.
- Individual colors can easily be dirtied by neighboring colors. You can rinse the whole set or individual pans, but you will lose a bit of paint in doing so.
- If you have to mix a large quantity of paint for a large wash, you will have to do a lot of rubbing on the pan cake. (Note: To preserve your softer watercolor brushes, you can use an old watercolor brush or a stiffer brush like an acrylic or oil paintbrush to rub the pan cakes.)

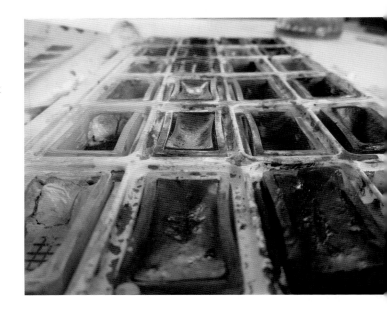

Watercolor Tubes

What are the advantages and disadvantages of watercolor paints in tubes?

- You have easy access to a large quantity of paint if you need to paint a very large wash.
- Paint in tubes is easier to mix with water since it is already in a paste or semiliquid form.
- You might waste a bit of paint at the end of the tube since it is difficult to get all the paint out, and sometimes paint dries inside a tube, making it virtually impossible to remove it.
- You can use watercolor in tubes much the same way you would use pan: Squeeze a bit of paint on a palette and let it dry. Add water to reactivate it. A bit of controversy exists between artists as some recommend against using dried tube paint since that is not the way it was meant to be used. Other artists see no difference in the quality of color or performance of dried tube paint. In my personal experience, I have only noticed that a bit more stirring is necessary to get an even wash made from tube paint that has been allowed to dry.
- Watercolor tubes are usually a bit more expensive than watercolor pans.

Should I Buy Professional Grade Paper and Paint?

Watercolor supplies can be quite costly. If you are on a budget I recommend buying a good-quality paper as the paper will make the most difference in your painting (more so even than the paint). In particular, if you are trying to lift up color with a stiff brush, you will find that student-quality paper won't take the rubbing very well. The paper might peel or you might end up with a hole in your paper.

Student Grade Paper | Professional Grade Paper

Student Grade
Ultramarine Blue paint

Professional Grade
Ultramarine Blue paint

Student Versus Professional Paper
Student quality paper might make it trickier to lift color with a stiff brush. The quality of the paint you buy will also make a difference, but that difference will probably be in color intensity and brightness.

Student Versus Professional Paint
The difference between student grade and professional grade Ultramarine Blue paint is mainly in the intensity of the color wash. The student quality paint is duller.

What Colors Should I Buy?

When starting with watercolor painting, the temptation might be to buy a large variety of colors; that art supply store can make you feel like a kid in a candy store! You will quickly learn, though, how to mix colors and that you might not need too many different paints after all. A good rule of thumb is to start with a cool and a warm of each primary color (for example, Lemon Yellow [cool] and Yellow Ochre [warm] or Ultramarine Blue [warm] and Prussian Blue [cool]).

Blue is generally considered to be a cold color, but Ultramarine Blue, for example, is on the warmer side of blue.

As well, yellow is considered to be a cool color, but Yellow Ochre is on the warmer side of yellow.

Below is my favorite color palette for landscapes and portraits. You might find that you are attracted to different colors that work better with your favorite subjects. Over time you will develop a personal palette of the colors you like the most, and that will be a step in developing your own style.

- Cadmium Lemon Yellow (Da Vinci)
- French Ochre (Daniel Smith)
- Yellow Ochre (Da Vinci)
- Cobalt Teal Blue (Daniel Smith)

- Cobalt Blue (Da Vinci)
- Ultramarine Blue (Da Vinci)
- Permanent Red (Da Vinci)
- Permanent Alizarin Crimson (Holbein)

- Burnt Sienna (Da Vinci)
- Burnt Umber (Daniel Smith)
- Lamp Black(Da Vinci)
- Sap Green (Da Vinci)

Basic Color Mixes

With the colors from my preferred palette, I can create a wide variety of color mixes. As a reference, here are a few mixing charts for tones of yellow, blue and red that you can obtain by mixing two colors from this palette.

	Permanent Red	Alizarin Crimson	Cobalt Blue	Phthalo Blue	Ultramarine Blue	Burnt Sienna	Payne's Gray	Violet
Cadmium Lemon Yellow								
Yellow Ochre								

Variety of yellow tones obtained from Cadmium Lemon Yellow or Yellow Ochre and another color.

	Cadmium Lemon Yellow	Yellow Ochre	Cobalt Blue	Phthalo Blue	Ultramarine Blue	Burnt Sienna	Payne's Gray	Violet
Permanent Red								
Permanent Red								

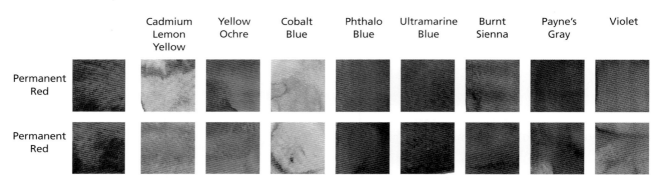

Variety of red tones obtained from Permanent Red or Alizarin Crimson and another color.

	Cadmium Lemon Yellow	Yellow Ochre	Permanent Red	Alizarin Crimson	Burnt Sienna	Payne's Gray	Violet
Cobalt Blue							
Phthalo Blue							
Ultramarine Blue							

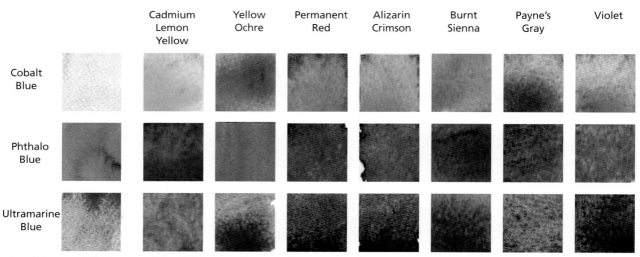

Variety of blue tones obtained from Cobalt Blue, Phthalo Blue or Ultramarine Blue and another color.

Mixing Landscape Greens

When painting landscapes, you will need to mix a variety of green tones for foliage. Being able to mix and paint greens that look believable and show enough variation is a must. Here are a few tips to help you mix a variety of greens.

- You can start from an already mixed green and add color to modify it. This is my favorite method and the one I use in almost every landscape I paint.
- Sap Green is an excellent choice for a base green for mixing as it is a natural-looking warm green. Most greens in nature are warm, but many of the greens you can buy are cold greens, like Winsor Green, and are rarely found in nature.
- You can mix green tones from blue and yellow, and then add a bit of red or brown if you need to neutralize the mix. Try not to combine more than three or four colors in any color mix. Doing so will increase the risk of making muddy colors. (Muddy colors are colors that look dull and opaque. They are usually the result of using too many colors in a mix. Mixing no more than three or four colors together for any color mix decreases the risk of getting muddy colors.)

A Word About Palettes

You will have many options to choose from when buying watercolor supplies. Here is a brief review of the palettes that are commonly available and what application each is most suited for.

Variety of green tones obtained from Sap Green and another color.

Sap Green

Sap Green with:

Cadmium Lemon Yellow	Yellow Ochre	Burnt Sienna

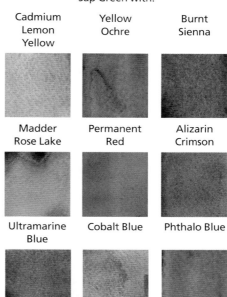

Madder Rose Lake	Permanent Red	Alizarin Crimson

Ultramarine Blue	Cobalt Blue	Phthalo Blue

Typical Watercolor Palette
This type of watercolor palette has wells and mixing areas. You can pour a bit of color from tubes into the wells and let them dry between painting sessions. It is easy to wash the mixing area without touching the wells.

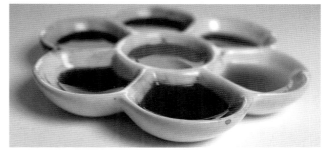

Round Ceramic Flower Palette
I like this kind of palette because it is portable and you can use a few of them if one is not enough. Its mixing space is limited, so you might want to use it in conjunction with a butcher tray or other surface.

Butcher Tray
A butcher tray is a tray covered in enamel, shaped in such a way that the water will run to the edges. It is very convenient for making small color mixes, and it's very durable.

BRUSHES AND ALTERNATIVES

Watercolor brushes come in a wide variety of shapes, sizes, qualities and prices. As a beginner, it is not necessary to buy the most expensive brushes, but it is certainly enjoyable to use quality brushes.

Watercolor brushes are softer than acrylic and oil brushes because watercolor is spread as a liquid on paper and won't offer as much resistance as a medium that has more body.

Also, with watercolor you might not want all your strokes to be visible (like, for example, if you are painting a flat wash). Softer brushes are a better choice in this case.

The most expensive brushes are usually made of rare natural materials such as kolinski sable (made from the winter coat pelt of a male kolinsky, a species of weasel). Expensive brushes hold more water, retain their shape better and last longer than less expensive synthetic brushes (although synthetic brushes have been improving by leaps and bounds).

To start, purchase an assortment of round brushes and flat brushes in sizes such as 1, 10 and 20, plus a few larger brushes for big washes (mop or hake brushes).

Everyday Brushes

Round Brush
The bristles of a round brush will form a rounded point when wet and will allow you to paint thin or thick lines depending on the pressure you apply to the brush.

Flat Brush
Flat brushes are great when you need to paint along a straight line.

Bright Brush
A bright brush is a flat brush with bristles that are a bit shorter and springier. It has a bit of an inward curve at the tip.

Angled Brush
The angled brush, a flat brush with bristles cut at an angle, is for me one of the most versatile brushes and is by far the type of brush I use the most.

Filbert Brush
A filbert (or cat's tongue) brush is like a flat brush with an oval-shaped end. It is commonly used to paint foliage or to blend washes.

Wash Brushes

Mop Brush
Mop brushes hold a lot of water and are very soft, which makes them ideal for painting large washes.

Hake Brush
Hake brushes are big and soft. They are designed to paint large washes.

Detail Brushes

Spotter Brush
A spotter brush is designed to paint small details.

Rigger Brush
A rigger brush is designed to paint thin lines and also works well for painting letters.

Silicone Brush for Masking Fluid
Masking fluid can be wiped off a silicone brush once dried.

Why is the Angled Brush My Favorite Brush?

An angled brush is very versatile and will behave much like a small round brush and a flat brush depending on how it is held.

An angled brush held sideways behaves like a round brush.

An angled brush held flat behaves like a flat brush.

About That Masking Fluid

Once masking fluid has dried, it is almost impossible to remove from a bristle brush. That's why it is usually recommended that masking fluid be applied with an old or very inexpensive brush. The brush should be rubbed with soap before it is used to apply the fluid. The soap prevents masking fluid from adhering to the brush. Some artists use toothpicks or skewers to apply fine lines of masking fluid. You can also find squeeze bottles of masking fluid on the market. But my favorite tool for applying masking fluid is a chisel-tipped silicone brush. It allows me to apply fine lines of masking fluid with the tip as well as larger areas with the flat side, and it is a more flexible tool than toothpicks or skewers. Once dried, masking fluid can be easily wiped off a silicone brush, and the brush will be like new.

Alternatives for Applying Paint

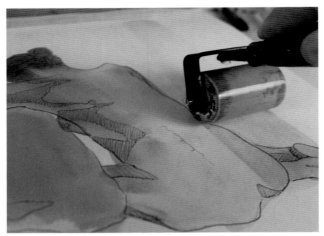

Roll
Watercolor paint can be applied with a brayer.

Sponge
You can apply paint with a sponge. This technique works well when painting texture. A sponge is often used to paint foliage. It's also a good idea to keep a wet sponge next to your painting area to remove excess water from a brush.

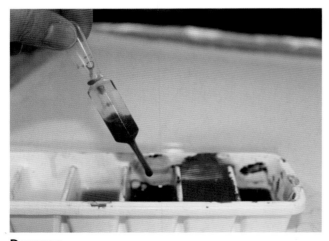

Dropper
Small and large droppers are very useful tools to have around the studio. A small dropper can be used to add drips to a painting. A turkey baster can be used to move water when mixing washes.

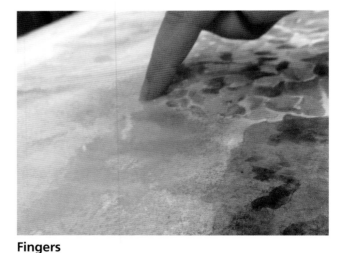

Fingers
Why not use your fingers to move the paint around? It is fun and reminiscent of the way children paint. If you feel like letting your inner child express him or herself, give it a try. In case you are concerned, watercolor usually washes off easily.

The List Goes On...

Many tools can be used to apply watercolor paint. Watercolor has the advantage of easily rinsing away, so any kind of material that will leave a trace on the paper can be fun to experiment with. You can stamp with corrugated cardboard, leaves, stamps; you can make monoprints with Plexiglas sheets; you can splatter paint with an old toothbrush. Use your imagination.

OTHER MATERIALS

Pencils, Watercolor Pencils and Crayons

There are many things you can do with watercolor crayons: You can use them to add details that would be difficult to paint. You can use them to add designs to a background, or you can use them to add brightness and contrast to some areas of a painting. Use them dry or paint over them after application.

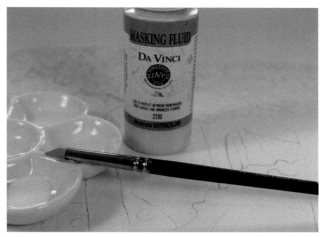

Masking Fluid

Masking fluid comes in handy when painting with watercolors because it is an easy way to prevent some areas from being painted over, especially if those areas are small or have complicated contours that would be too tricky to paint around. You can preserve areas of white paper or areas that have already been painted (although you might lose some of the paint pigments when the masking fluid is removed).

Stir, Do Not Shake, and Why is It So Stinky?

Masking fluid has a rather unpleasant odor due to the ammonia in its composition that acts as a preservative for the latex in suspension that is its main ingredient. Avoid shaking the bottle, as this causes the latex to accumulate into clumps. Stir it instead. Masking fluid may be white, but usually a very light gray or yellow color is added to make it more visible. Always let masking fluid dry naturally.

Tissues

There are many ways to lift watercolor and water from your paper but tissues are the easiest and fastest. It is always a good idea to keep a box of lotion-free tissues close at hand.

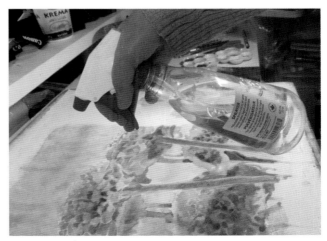

Spray Bottle

Depending on your style of painting, you might have more or less use for a spray bottle. I use a spray bottle a lot because I like to spray paintings with water after they are finished. The paint moves and mixes freely and loosely with the water and gives my paintings an interesting "dirty" look. A spray bottle can also be used to keep paint moist on a palette or to add a bit of water to a mix or to keep the watercolor paper wet when painting wet on wet.

Hair Dryer

Feeling impatient? Tired of waiting for that wash to dry? You can reduce drying time by using a hair dryer. You'll get the best results if the heat isn't too hot, and don't let the hair dryer get too close to the paper—you don't want to damage the fibers.

And try not to be overzealous with the force of the air you are blowing onto your painting—a high-pressured airflow can cause drips of paint to blow across your paper.

Also, a hair dryer should not be used to dry masking fluid. This might be tempting since masking fluid takes a long time to dry, but it can cause the masking fluid to bond too strongly to the paper, making it very difficult to remove.

Once masking fluid has air dried, it is possible to use a hair dryer to dry subsequent layers of paint without negative consequence.

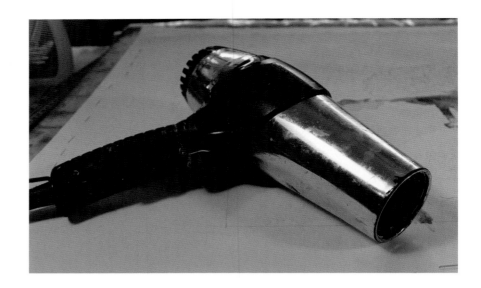

Soap

Soap can be added to watercolor to add texture. It also works well for removing greasy fingerprints that can repel paint from the paper. Soap is most often used with Yupo paper; it makes paint more manageable by adding body to it.

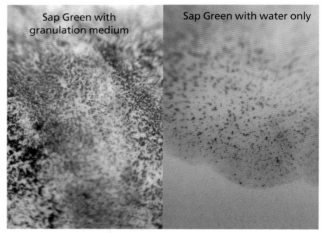

Granulation Medium

Granulation medium is an additive that causes a watercolor mix that would not otherwise granulate to granulate. Results will vary depending on the ratio of medium to water in your mix. For optimal effects, mix color pigments directly into granulation medium.

Alcohol, Acetone, Bleach and Lemon Juice

Painting with Alcohol and Acetone

Alcohol and acetone work more or less the same way with watercolor. Used as solvents, they create interesting textures when mixed into your washes. Or, if you drip them onto a wet wash, you'll see round highlighted shapes.

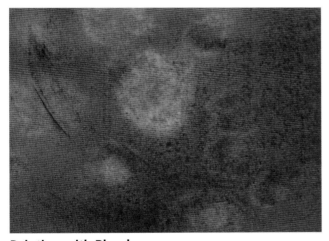

Painting with Bleach

Adding bleach to a wet wash will result in highlights. Bleach works better with certain pigments than others and might alter the hue of the subsequent washes you paint on top of any bleached areas.

Bleach will also compromise the archival properties of your paper, so this is a technique that I recommend only for practice or for fun.

Painting with Lemon Juice

Lemon juice will result in an effect similar to bleach on a wet watercolor wash. Even though it is a fun effect, I would not recommend using lemon on an important painting. When you paint with lemon juice, you add acidity to your pH neutral paper. Therefore, your work won't be archival, and your painting may degrade. But it is perfect for those times you feel adventurous.

What is Archival Friendly and What is Not?

Before using anything other than water and paint in your paintings, you might want to consider how important it is to you to preserve the archival properties of your paper. Watercolor paper is made from cellulose fibers that have been rendered pH neutral for preservation purposes. Using a handmade soap, for example, will add a basic pH to your paper. Using lemon juice will add an acidic pH. Using bleach will cause the sodium ions in your paper to accelerate the degradation of the cellulose fibers.

TRANSFERRING YOUR DRAWING
Can I Draw Directly on the Watercolor Paper?

Depending on your drawing style, it is possible to draw directly on watercolor paper and that is certainly the best way to go when possible. I don't recommend drawing directly, though, for very large or complicated drawings since you'll be more likely to need to make corrections and erase pencil lines. Too much erasing will leave marks on the paper, and those marks will be even more visible once painted on.

That said, the amount of erasing your paper can withstand without showing damage depends on your paper quality. You will certainly be able to erase more on thicker, professional-quality papers than on thin student-quality paper.

Sometimes, when working from a reference photo, I will draw a grid on the photo and my paper to help with accuracy. I don't want that grid (or the marks left from erasing) to be visible on the finished painting, so I work on drawing paper and then transfer that drawing onto watercolor paper.

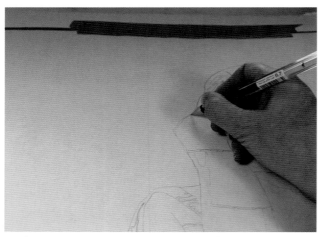

Carbon Paper Can Be Used to Transfer an Image
Carbon paper is a thin paper covered with ink or pigment and a light layer of wax or polymer. Carbon paper will produce a more visible line than pencil does. Also, the light layer of wax or polymer will transfer onto your watercolor paper and will make your lines a bit water-repellent, which can be an advantage as it will help you paint neat edges.

Projector
You can also use a projector to transfer your image onto paper. This method will make it more difficult to see tiny details—you will lose a bit of the resolution when projecting. You also have to be careful to check that the surface you are projecting onto and the surface on which the projector is sitting are perpendicular. Angles that are not perpendicular will deform the projected image.

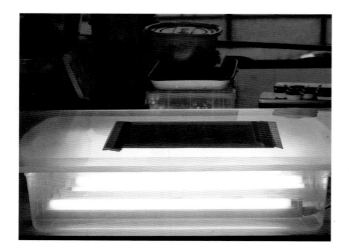

Light Box
Using a light box is one of my favorite methods for transferring images. You can use any pencil you like to add many details to your paper. Of course, the thicker the paper, the less detail you will be able to transfer because you will see less of the original image through thicker paper. Here's a tip: Light boxes are easier to use in a darkened room.

Making Your Own Light Box

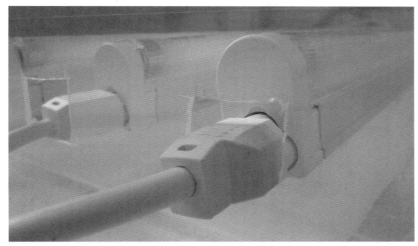

It is easy to make your own light box and you can make it for a very reasonable price.

YOU WILL NEED:

Storage box (I chose a clear Rubbermaid latch storage box with four evenly spaced holes cut into it (You'll put the bulbs through the holes, so size them accordingly.)

4 fluorescent, linkable undercabinet lights (You want the bulbs to produce enough light but not too much heat.)

Box cutter or similar tool

Extension cord

Piece of Plexiglas (I already had one that had been sanded, so its surface is frosted, which helps to diffuse the light.)

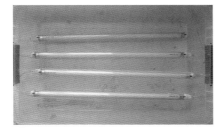

1 Position Fluorescent Bulbs
Link the fluorescent tubes together and plug the last one into an extension cord.

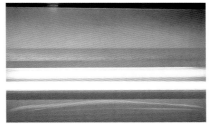

2 Place Plexiglas Over the Box
I placed a frosted piece of Plexiglas on top of the box since the box cover won't be flat enough or sturdy enough to draw on. The frosted quality helps diffuse the light. You can make frosted Plexiglas by sanding a sheet of transparent Plexiglas. Regular (unsanded) Plexiglas will work too.

Fluorescent lights don't heat up like other bulbs, so you shouldn't have to worry about the plastic of the box melting.

3 Save the Original Box Lid
When you are not using the light box, simply store all the cords inside the box.

My Drawing is Showing Through the Paint

Here again it depends on your style and your personal taste. Personally I really like drawing marks to show through the paint, because I think the mix of drawing and painting adds interest to the image. But some artists don't like the marks to show. I would advise them to use a pencil that is on the hard side (like a 2H) with a very light hand. It is possible to use an eraser to remove visible pencil marks after the paint has dried, but be careful as erasing will most likely lift off some of the paint as well.

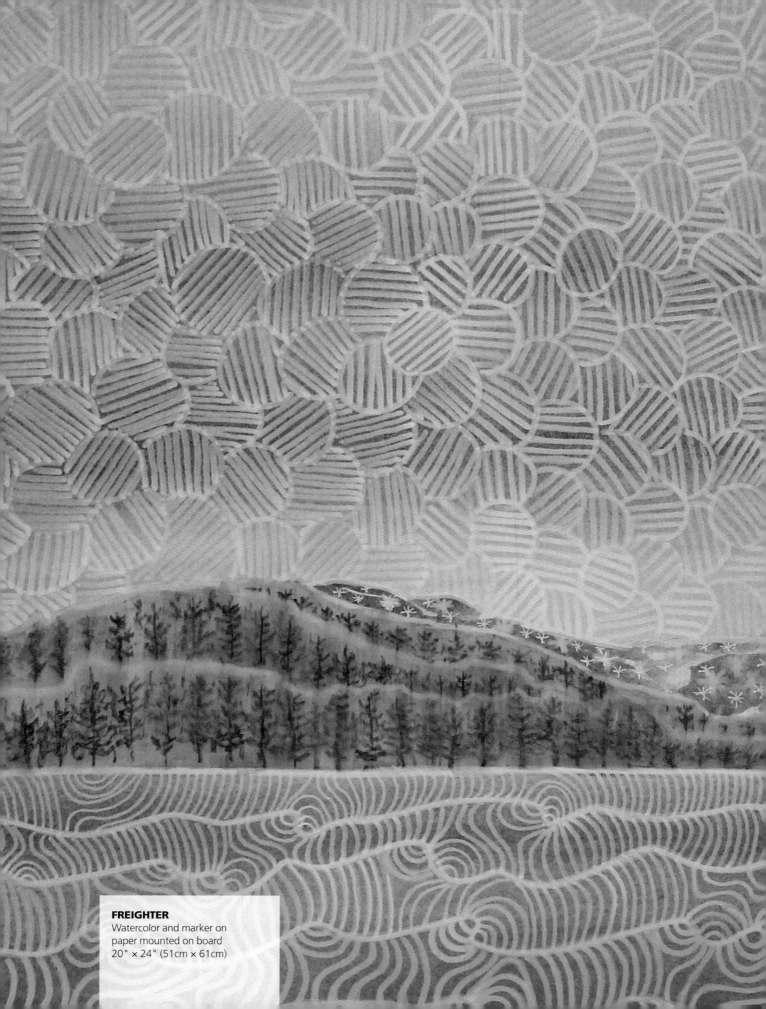

FREIGHTER
Watercolor and marker on
paper mounted on board
20" × 24" (51cm × 61cm)

Basic Techniques

WASHES: THE BASIS OF WATERCOLOR PAINTING

What Exactly is a Wash?

Wash is a confusing term; it can refer to the mix of pigments in water you are going to paint with and it also means any painted area on your paper. To avoid confusion, I will use the word *wash* to refer only to a painted area on your paper and *painting mix* to refer to the mix of pigments and water you use to paint with.

Laying a wash is one of the fundamental techniques of watercolor painting, but it's also a tricky technique to master. The size of a wash can be very large, for instance, if it's part of a background. It can also be very small if it is a detail in your painting. Washes can be flat (the same color and tone all over), graded (a gradual change in color, tone or both) or variegated (different colors and tones in various areas). Most of what you will paint with watercolors can be considered a wash.

Most of the time, the first washes that are painted are background washes. They are usually painted with large soft brushes.

What are the Different Ways to Apply Paint?

Wet on Dry
Wet paint is applied to dry paper.

Wet on Wet
Wet paint is applied to wet paper, or two freshly painted areas of wet paint are allowed to mix on the paper.

Dry on Dry
When trying to render certain textures, you can use a drybrush technique, which consists of painting with a brush that is almost dry onto dry paper. Painting dry on dry, the brush carries a bit of paint and very little water.

Washes can be flat and almost perfect or show irregularities like back runs. This portrait has a very textured and imperfect background that shows some back runs here and there.

Granulation can be an effective addition to a wash. Here Ultramarine Blue was layered on top of the pink of the beret, resulting in a visible granulation texture.

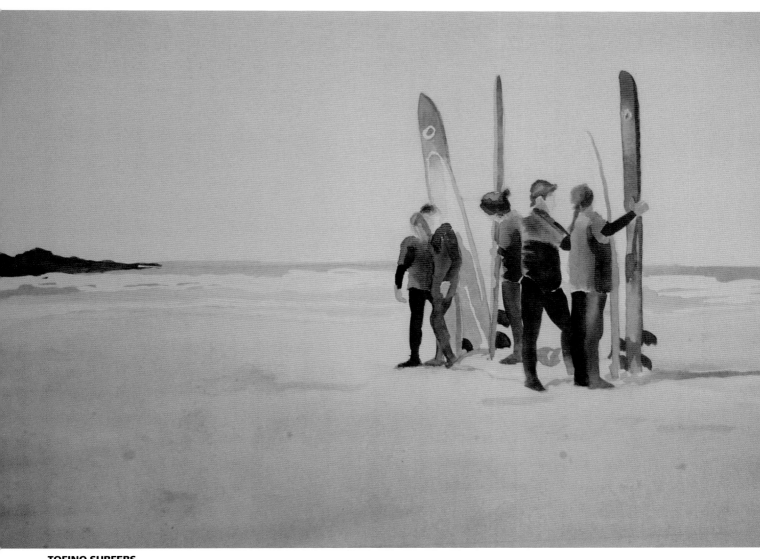

TOFINO SURFERS
Watercolor on paper
15" × 22" (38cm × 56cm)
The background in this painting is an example of a flat wash created
by painting wet on dry: Wet paint was applied to dry paper.

Paint a Flat Wash: Wet on Dry

A wet-on-dry flat wash is a wash painted on dry paper. Incline your paper to a 30° angle. Paint horizontal lines, loading your brush in the paint mix at the beginning of a line and dragging it across the paper. Because of the 30° angle, the paint will flow slowly down the paper. A bead will form along the lower edge of your brushstroke. When adding the next stroke of paint, paint along that bead, slightly overlapping the preceding line so you pick up the paint collected in the bead. Your wash will be flat and even, with no beads or edges showing.

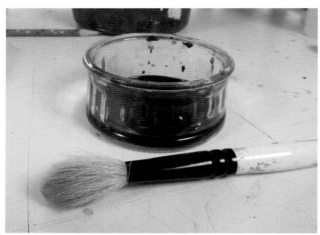

1 Mix Paint and Gather Necessary Materials
Prepare your painting mix and any materials you will need. Watercolor dries fast and you have a limited amount of time to paint a wash.

2 Paint Horizontal Lines on Your Paper
Holding your paper at a 45° angle, paint lines with a soft wash brush. Dip your brush in the painting mix at the beginning of each line.

3 Overlap Your Paint Lines
Each new line should overlap the preceding one just enough for the paint to move in a slow downward motion.

4 Wipe Off Excess Paint
Wipe off the excess paint at the bottom of the paper so no back run forms there.

WATCH IT! Watch Sandrine **Paint a Flat Wash Wet on Dry**. Visit **ArtistsNetwork .com/fearless-watercolor**.

What Tips Will Help Me Paint Better Wet-on-Dry Flat Washes?

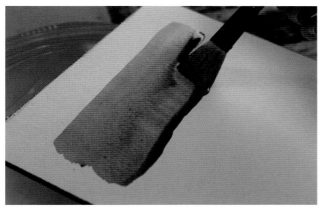

Keep the Lower Edge, or Bead, of Your Paint Wet
That means making sure your brush is well loaded with paint and that you paint quickly and with even pressure. If the paint dries before you draw your next line through your bead, you will see a line or stripe in your wash.

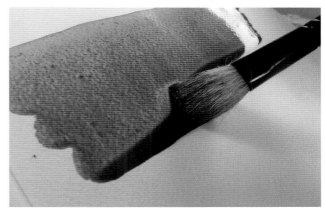

Watch Your Bead Size
If it gets too big, the bead could drip down the paper. If that happens, try to finish painting your wash as quickly as possible, before the drip has time to dry. You might be able to eliminate the drip by painting through it.

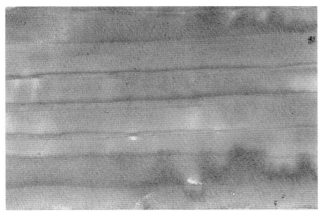

Visible Lines or Streaks in a Wash
This photo shows lines that occurred because the brush wasn't loaded with enough paint and water and the lines had time to dry. A premixed wash that hasn't been mixed enough may result in similar irregularities in the color of the wash.

I've Got Blooms in My Wash
When you are finished painting your wash, remove any excess paint using a dry or "thirsty" brush or a tissue paper. A puddle of paint on the edge of a wash, if not removed, might dry to form a bloom.

I Think I Messed Up. What Can I Do?

- **My wash is too light!** This is easily fixed; you can simply add another wash layer on once the first one has completely dried.

- **The wash is too blue, too red, too yellow…** Try laying on a light wash of the opposite color on the color wheel. If you have a wash that's too red, for example, add a (very) light green wash.

- **The wash is too dark or uneven.** Try brushing the paint off with a stiff brush loaded with lots of water. You could even try soaking your paper in a bathtub—you might be able to rinse the paint away. My best tip for you is to always go for a lighter wash and slowly add layers until you reach the desired color intensity. Remember, it's always easier to add color than to take it away.

- **I have blooms and the wash is uneven!** An uneven wash can also look very good and this is sometimes part of the charm of watercolors. Before taking any drastic measures, make sure that mistake is not one of those happy accidents that can actually add to your painting.

Paint a Flat Wash: Wet on Wet

Painting wet on wet will produce blurry or fuzzy edges. A well-balanced painting will usually have a variety of edges and at least one focal point that has more definition and contrast. So although you can achieve a very interesting atmospheric effect with wet-on-wet painting, your painting will probably include at least one area with a bit more definition.

Before painting a wet-on-wet wash, wet your paper by brushing it with clean water; this will help ensure an even wash. It will also cause your wash to be a bit lighter since you are essentially diluting your paint. Compensate for the dilution by making your paint mix a bit darker than if you were painting a wet-on-dry wash.

With the wet-on-wet technique, you need to paint quickly since you don't want the paper to dry before you are done. But you will have the option to go back into an already painted area to make corrections. You can also leave your paper flat while you paint and tilt it in different directions after you have finished painting to help even out the wash.

This technique works well when the background is the first thing you'll paint because you'll need to wet the whole paper before you start. It's also a convenient technique for large areas with simple outlines. If you need to paint a smaller area or an area with intricate borders, I recommend the wet-on-dry technique.

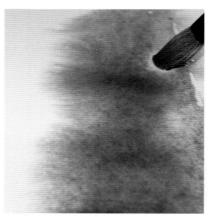

In Landscapes
Painting wet on wet can produce interesting atmospheric effects, like these trees painted over the pinkish horizon line.

In Still Lifes
Painting wet on wet also works well in flower themes if you prefer a loose style. When painting on Yupo paper, colors mix quickly when painted in a wet-on-wet technique.

In Portraits
A nice effect is achieved by painting the first layers wet on wet, keeping edges soft. Once the paper has dried, add more definition by painting the features wet on dry.

What Tips Will Help Me Paint Better Wet-on-Wet Flat Washes?

- Painting a wash wet on wet works better if you paint quickly; the wash should be finished before the paint starts to dry.

- The paper should be evenly wet before you begin applying your paint mix.

- Let's say you are painting a green apple on a red background; preserve the apple area with masking fluid, even if the green is darker than your red background. Otherwise the red will dull the green of the apple.

- Preserve the areas where you will paint lighter-colored elements with masking fluid before painting washes.

- Wait until a background wash is totally dry before you paint on top of it. You can always re-wet areas of the wash later if necessary.

- Your paper should be prestretched and dried before you begin this technique; you will be using a lot of water, which can cause unstretched paper to buckle.

1 Prepare Your Paint Mix and Gather Materials

Start by mixing a sufficient quantity of water and paint. Because you will brush the area you want to paint with plain water before applying the paint, your mix needs to be a bit darker than if you were to paint directly on dry paper.

2 Brush Your Paper with Water

Brush your paper with a large brush and plain water. (Your paper should be prestretched.)

3 Apply Paint Mix

While your paper is still wet, apply your paint mix. If you are painting the entire paper, you don't need to paint lines as you would in a wet-on-dry technique; just apply the paint quickly over the whole surface.

4 Tilt Your Board to Spread the Paint

Once the paper has been painted, you can tilt your board in various directions to help the pigments spread evenly on the paper. You can also eliminate extra water by letting it drip from one corner of the board, as shown.

5 Remove Excess Paint

Don't forget to blot the corner with a tissue to prevent a bloom from forming.

WATCH IT! Watch Sandrine **Paint a Flat Wash Wet on Wet**. Visit **ArtistsNetwork.com/fearless-watercolor**.

GRADED WASHES

A graded wash is a wash that will change in tone or color gradually. It can be a bit tricky to get a perfect gradation for a change of tone or color, but imperfections are sometimes part of watercolor's charm.

As with a flat wash, a graded wash can be painted wet on dry or wet on wet. I find the wet-on-wet technique easier and more forgiving, but it is best used in the first full coverage layers of a painting. For the smaller areas to be painted later in the process, the wet-on-dry technique is a better and more convenient choice.

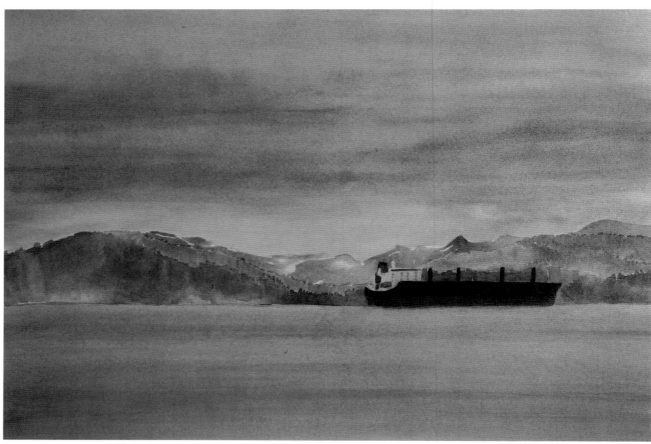

Example of a Graded Wash
The sky in this painting is a graded wash that transitions from pink to blue. A graded wash is a wash that gradually changes tone, color value or both.

Before Painting Your Wash

- Make sure you have enough paint premixed with water. You might not have enough time to make a new mix and even if you do, this new mix will most likely not be the exact same as the color you started with.

- If you are painting a graded wash with two colors, use two different brushes—at least at the beginning—so you keep both colors fresh in their mixing containers.

- To avoid any buckling of your paper, you can stretch it a day before so it has enough time to dry.

Paint a Graded Wash: Wet on Dry

Remember to paint on paper that has been stretched; you don't want it to buckle, nor should you stretch it just before applying the wash. Prepare a sufficient enough quantity of paint mixed with water to finish the entire wash.

1 Begin Painting a Wet-on-Dry Wash

Start by painting your wash with a big soft brush as you would for a regular wet-on-dry wash, holding your paper at a 45° angle and moving your brush in lines so it just overlaps the bead that formed on the previous line.

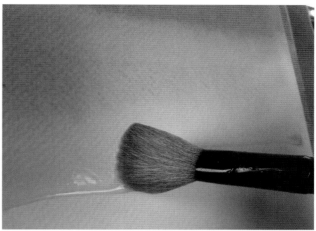

2 Dip Brush in Water

Wherever you want your wash to become lighter, dip your brush in clean water instead of dipping it in the paint mix. You don't need to rinse it. Ideally you want a bit of pigment to remain on the brush—the transition will be softer. Continue painting your wash and dipping the brush in clean water. The wash you are painting will become lighter and lighter until it is eventually just water.

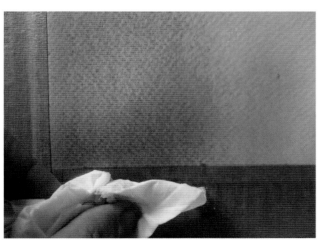

3 Remove Excess Paint

Don't forget to remove the paint that might have accumulated in the corner of the paper; doing so will help you avoid the formation of a bloom.

4 Allow Paint and Paper to Dry; Begin Second Color of Wash if Desired

If you want to paint a graded wash with two colors, let the first wash dry and then paint your second wash, starting on the opposite end of the paper.

WATCH IT! Watch Sandrine **Paint a Graded Wash Wet on Dry**. Visit **Artists** Network.com/fearless-watercolor.

Paint a Graded Wash: Wet on Wet

You will need a sufficient enough quantity of your mix and water to complete a full wash. You will also have to pay extra attention to the stretching of your paper because this method requires you to use more water than others.

1 Apply Water to the Paper
Once your paper has been stretched and is dry, apply a layer of clean water over the entire surface using a soft brush. If you want, you can also paint the wash just after your paper has been stretched and is still wet.

2 Apply Full-Strength Paint
Start by painting the area that will have the full-strength color. Your lines need not be perfectly applied (like with the wet-on-dry method), but stay only in the darkest area of your painting.

3 Tilt the Paper to Spread the Pigment
Tilt your paper so the pigments move slowly across the paper. You want the painted area to move into the area saturated with clean water. If you find you have too much paint and/or water, remove the excess by tilting the paper at an angle parallel to the gradation (as shown).

4 Allow Paint and Paper to Dry; Begin Second Color of Wash if Desired
Here is the graded wash once dried. If you want a two-color graded wash, wait for the first wash to dry and then paint the second wash, starting on the opposite end of the paper.

I Messed Up. What Can I Do?

If your graded wash is the first wash you painted on the paper, the easiest fix might be to wash it off in a bathtub. You can also add more layers to make imperfections less visible.

WATCH IT! Watch Sandrine **Paint a Graded Wash Wet on Wet**. Visit **Artists Network.com/fearless-watercolor**.

VARIEGATED WASHES

A variegated wash is a wash that will change in tone and/or color in a nongradual way. Most variegated washes will be painted using a wet-on-wet technique.

As with most wash techniques, you need to monitor the amount of water and the amount of pigment on your paper and on your brush. To get soft edges, the paper needs to be wet but not so wet that you can't maintain control over the paint. How do you know if your paper is "just right?" Hold your paper at an angle to the light. Can you see that all the water has been absorbed by the paper? You want the paper to look shiny but you don't want any water to pool or move. If that's what you see, you are good to start painting.

And one final note: You might need to lift color from your variegated wash. This can be done while the paint is still wet or after the paint has dried.

DOWNLOAD IT! Visit **ArtistsNetwork .com/fearless-watercolor** for a downloadable PDF: **Fixing Mistakes and Lifting Color**. Sandrine shares techniques for fixing what you might not like in your work.

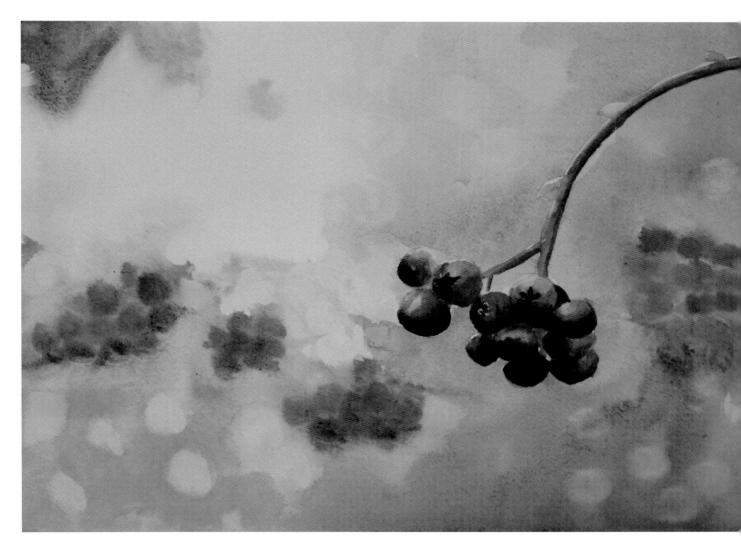

BERRIES
Watercolor on paper
9" × 11" (23cm × 28cm)
The background for this painting is a variegated wash, which in this case, is a background painted wet on wet. It changes in tone and color but not in a gradual way.

Paint a Variegated Wash

Before starting to paint the wash, you will need to have your drawing ready, and you might want to preserve a few white areas with masking fluid. If the subject you are painting in front of your variegated wash is lighter and has intricate edges or details, you might want to mask the entire area so you can paint the background more freely.

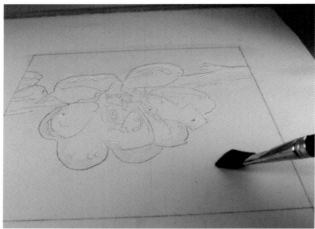

1 Wet the Paper
Wet the background with clean water and a soft brush. You want the paper to be wet but not too wet, just to the point where no water sits on top of the paper and it will soon start to lose its shine.

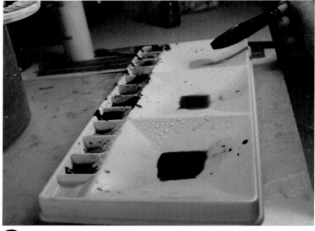

2 Prepare Your Color Mixes
Prepare the colors you are going to use to paint your variegated wash background.

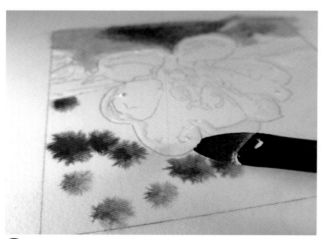

3 Place Color
Paint the background by placing touches of colors where you want them and letting them mix wet on wet.

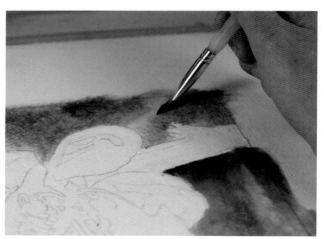

4 Lift Color as Desired
You can also lift color with a dry brush or a tissue paper in areas that you want to appear lighter.

WATCH IT! Watch Sandrine **Paint a Variegated Wash**. Visit **ArtistsNetwork** .com/fearless-watercolor.

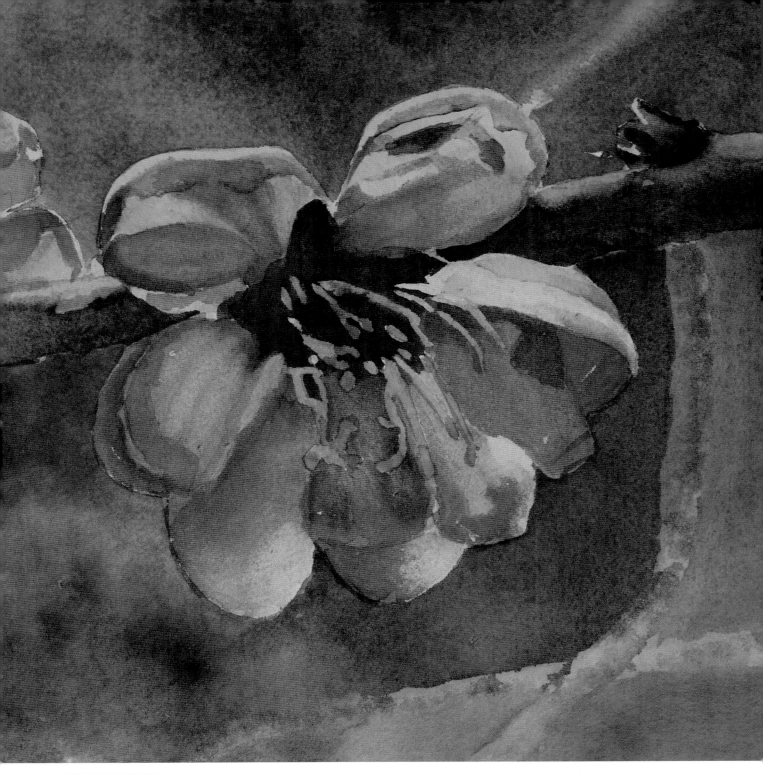

CHERRY BLOSSOM
Watercolor on paper
12" × 12" (30cm × 30cm)
The background for this painting was painted using a wet-on-wet technique so the colors would mix on the paper and the edges could be a bit fuzzy. Color was lifted while still wet in the areas where the branches are in the background. After the background was dry, I worked on the flowers in the foreground; the edges of these flowers were painted wet on dry, so they are more defined.

WATCH IT! Watch Sandrine **Build Texture by Layering Washes**. Visit ArtistsNetwork.com/fearless-watercolor.

PROPERTIES OF YOUR PIGMENTS

Primary colors are colors that cannot be obtained by mixing other colors from the color wheel. Because the color names and hues vary depending on the paint brand you are using, there is no universal primary blue, yellow and red. If you look at your favorite brand's website, though, it will often specify which colors are the closest to the primaries or which it considers to be the primaries.

For example, according to its website, Winsor & Newton considers Winsor Lemon, Winsor Blue (Red Shade) and Permanent Rose to be its primary colors.

Secondary colors are obtained by mixing two primary colors together. So, with three primary colors you can mix three secondary colors:

- blue and yellow = green
- blue and red = violet
- red and yellow = orange

Tertiary colors are obtained by mixing a primary and a secondary color that lies next to that primary on the color wheel. For example, green and yellow mix together to make a yellow green.

You can mix six tertiary colors on a twelve-color wheel.

Primary, secondary and tertiary colors on a twelve-color system color wheel

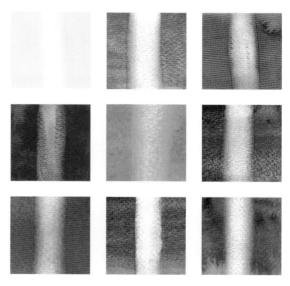

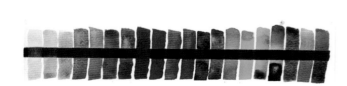

Transparent Versus Opaque Watercolors

Watercolor pigments are more or less all transparent. That said, though, colors labeled transparent will let the white of the paper show through and they will look more luminous than opaque colors. Opaque colors will obscure more of the white of the paper, and they will have a duller appearance. When mixing watercolors, you will get a more transparent color if you mix colors that are transparent to start with.

To determine the transparency of your pigments, draw a black line with a waterproof black marker across a piece of watercolor paper. Let the marker dry and then paint a swatch of your color over the line. Can you see the black beneath the paint? The more you can see the black line, the more transparent the paint is.

Staining Versus Nonstaining Watercolors

Watercolor pigments all have staining properties; some are just more staining than others. This is an important factor to consider, especially if you want or need to lift color. You can test the staining properties of your pigments by trying to lift paint with a stiff brush and clean water. Brown colors are notoriously easy to lift, which makes them easier to correct but tricky to layer since the pigments may unintentionally lift.

MIXING COLORS

When painting with watercolors, you can mix colors in different ways.

- In a mixing well on your palette: You might, for example, mix a red with a blue to make violet.
- On your paper: You could mix the same blue and red watercolors on your paper and let them mix wet on wet to achieve the same violet color.

- By layering colors: You can paint a layer of blue, let it dry, and then paint a layer of red on top.

 Each of these three techniques has advantages and disadvantages, and you can use the three of them in different areas of the same painting depending on your desired results.

Mixing Paint on Your Palette
You usually get a more homogenous color this way. You can add a bit of variation by not mixing your colors completely or by dipping each side of your brush in one color and letting the colors mix imperfectly.

Mixing Colors Wet on Wet
With this technique, you will get a color that definitely has variation in it. In the violet area, you can clearly see the blue and the red that mixed to make the violet.

Mixing Colors by Layering
This technique gives you more control over the final color since you can layer many washes until you are satisfied. It also usually produces very luminous colors that have a glowing quality. They look quite different from the colors you get from mixing the pigments together before painting.

A Few Things to Know About Mixing Watercolors on Your Palette

- If you want to paint directly on your paper, without layering colors, it is helpful to have the colors you will use ready and premixed on your palette (or in a small container if you will need a large quantity). You can also prepare colors that you will blend on the paper, wet on wet. In any case, it will be easier for you if your colors are ready before you start to paint. Watercolor can dry quickly and you want to avoid having to mix colors in a rush.

- You can paint on either dry paper or wet paper. If your paper is wet, colors will appear lighter after they dry. Consider this while preparing your color mixes.

- It is also important to consider how wet your paper is. The speed at which the watercolor pigments will move depends on how much water is on your paper. The more water, the faster the pigments will move. The faster the paint is moving, the further away it will move. If you want to achieve a slightly blurry edge but still have some control over your design, paint on paper that is slightly wet.

THE BASICS OF COLOR THEORY

You don't need to know all the theory behind colors and their usage, but a basic knowledge of color schemes will surely help your paintings have more impact. The basic color schemes are analogous, complementary, split complementary and triadic.

Analogous Color Scheme

An analogous color scheme uses three or more colors that are contiguous on the color wheel. One of the colors is dominant and the others are accents. This color scheme produces very harmonious paintings.

Complementary Color Scheme

A complementary color scheme uses two colors that are opposites on the color wheel. One of the two colors is dominant and the other is used as an accent. This color scheme produces paintings with high contrast and vibrancy.

Split Complementary Color Scheme

A split complementary color scheme is similar to a complementary color scheme. In addition to the complementary colors, the colors on each side of your main color are also used.

Triadic Color Scheme

The three colors used in a triadic color scheme are evenly spaced around the color wheel—every fourth color is selected.

Avoiding Muddy Colors

Muddy colors are colors that have lost their glowing effect and their transparency. Muddy colors are not always a bad thing, as a bit of a dull color in a painting can help a transparent or bright color become the center of attention. But you don't want all of your colors to be muddy, or your whole painting will look dull.

The best way to avoid mixing muddy colors is pretty simple: Never use more than two or three colors to mix a new color.

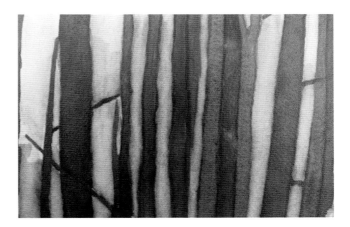

Mixing Grays

The easiest way to mix grays is to mix complementary colors: green and red, yellow and violet, or blue and orange. Here are my favorite gray mixes:

Gray mixed from complementaries Alizarin Crimson and Viridian Green. This is a great mix when you need a very dark gray. Alizarin Crimson and Viridian Green are intense colors, so the resulting mix is quite dark. You can add water to lighten the mix, if desired.

Gray mixed from complementaries Cadmium Lemon Yellow and Violet. This mix creates a very soft and luminous gray.

Gray mixed from complementaries Ultramarine Blue and Burnt Sienna (a very dark orange). This mix creates an excellent natural-looking gray for landscapes. This mix also has a tendency to granulate and produce very nice effects on textured paper.

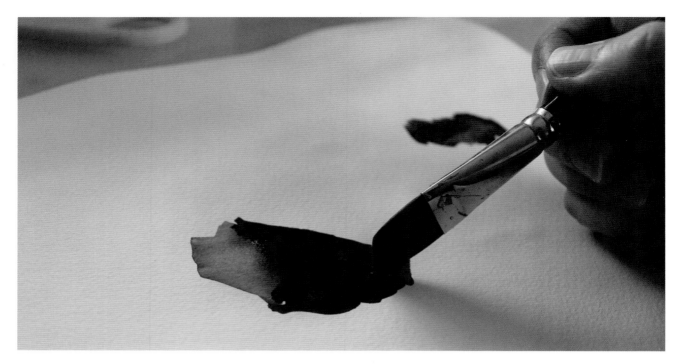

Mixing Darks

When you need darks in a painting, you can use a dark gray or a black straight from the tube or the pan, or you can mix your own. Black from the tube is usually very neutral. You will get a more vibrant black if you mix (or layer) your own darks. You'll also be able to make very subtle variations. For example, try mixing a black with a hint of red or a black with a hint of blue. The resulting colors are far more interesting and vibrant.

Remember, watercolor dries to a lighter shade than it appears to be when it's wet. To get a very dark black you might need to paint a few layers, allowing the paint to dry between applications, until you achieve the desired darkness.

Ultramarine Blue and Burnt Sienna

Ultramarine Blue and Burnt Umber

Alizarin Crimson and Winsor Green

Alizarin Crimson and Prussian Blue

Dark Purple and Sap Green

Payne's Gray (top) and Yarka Neutral Tint Black (bottom)

(Included here so you can compare these "out of the tube" darks with the mixed darks.)

Mix Colors to Paint a Color Wheel

When starting out with a new medium like watercolor, it can be tempting to buy many different colors but you don't actually need many colors to paint. In theory, you should be able to mix all the colors in the color wheel using the three primary colors. But I find that some colors are difficult to obtain that way, such as a bright, beautiful Cerulean Blue, for example.

A good exercise to teach you the variety of colors you can mix from just the three primary colors is to paint a color wheel.

1 Prepare Primaries
On a clean palette, mix a bit of Ultramarine Blue, Cadmium Lemon Yellow and Permanent Red with water, each in a separate well.

2 Mix Secondary Colors
Using a dropper, mix each of the primaries with another primary to obtain the three secondary colors. You'll now have six colors: blue, green, yellow, orange, red and violet.

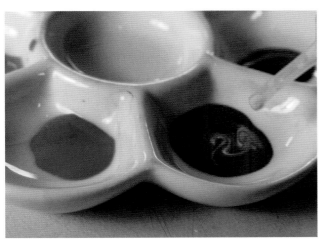

3 Mix Tertiary Colors
Mix each color with its neighbor to get the six remaining colors. (I used a second six-well palette for the tertiary colors.)

4 Paint the Color Wheel
Draw a circle on watercolor paper. (Trace around two small plates of different diameters and then divide each quarter into three equal parts.) Start painting with your mixes in the order of the color wheel. Wait until one color has dried to paint next; you don't want the colors to mix on your paper.

MIXING COLORS ON PAPER
Painting Wet on Wet to Mix Colors

Painting wet on wet is a great way to take advantage of the fluidity of the watercolor medium. The paint is more difficult to control wet on wet, but it is the wet-on-wet areas of a painting, after all, that make a watercolor painting look like watercolor.

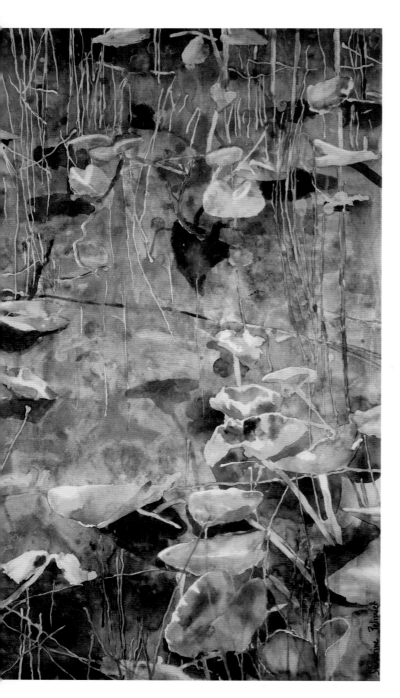

ONE MILE LAKE
Watercolor on paper mounted on board
30" × 18" (76cm × 46cm)
Private collection
Paying attention to edges is particularly important when depicting believable waterscapes. In this painting I wanted the reflections in the water to be soft with blurry edges so they would contrast nicely with the grass and the lily pads. Thus all the water in this painting was painted using a wet-on-wet technique.

SOPHIE, IN THE STUDIO
Watercolor on paper
22" × 15" (56cm × 38cm)
Most of this portrait was painted using a wet-on-wet technique to keep it soft. Just a few details and the features were painted wet on dry (after the wet-on-wet layers had time to dry) so they could be the focal point of the portrait.

Paint a Sky: Wet on Wet

Wet-on-wet painting is a technique that will produce mostly soft edges, so it is very well suited to painting skies. In this demo, the colors of the sky are painted wet on wet, and some of the paint is lifted with a tissue or scrubbed off with a stiff brush and water.

YOU WILL NEED

Da Vinci Yellow Ochre, Cadmium Yellow, Ultramarine Blue, Prussian Blue

Daniel Smith Burnt Umber

Holbein Permanent Alizarin Crimson

(or similar colors of your choosing)

Other materials:

140-lb. (300gsm) cold-pressed paper, stretched on board

Large wash brushes, a medium round brush, a few angled brushes

Masking fluid and silicone brush

Tissues

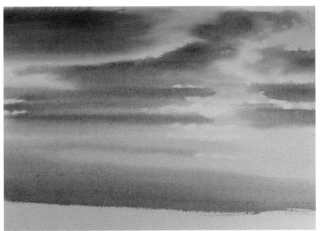

1 Paint Wet on Wet

Start by wetting your paper with clean water. Working from a reference picture, paint a few areas of color wet on wet. The colors will mingle on the paper and they should have soft edges.

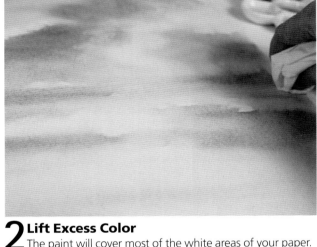

2 Lift Excess Color

The paint will cover most of the white areas of your paper. You can lift color to define the shape of the clouds using a tissue. Avoid using the same part of the tissue repeatedly as it could act as a stamp and transfer some of the lifted paint back onto the paper.

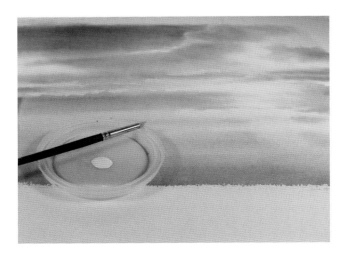

3 Soften Edges and Lift Color

Once the paint has dried, you can also soften any hard edges with a dry brush and water. You can also use this method as a way to recover the white of the paper.

WATCH IT! Watch Sandrine **Paint a Sky Wet on Wet**. Visit **ArtistsNetwork.com/ fearless-watercolor**.

LAYERING COLORS

When layering colors, it makes sense to use the most transparent colors of your palette, as you want the colors underneath to show as much as possible through successive layers.

The concept here is similar to color mixing on paper except that we are separating colors and letting the paper dry between each layer so the colors don't get muddy. This method is very effective for painting skin tones in portraits, as it gives you more control over tonal value and edge quality. I also sometimes use it in landscapes and still lifes.

You can choose any number and choice of colors for layering, but using the three primary colors will allow you to obtain almost any color. When layering with primary yellow, blue and red, always start with the yellow layer since it is the least transparent color of the three.

I compare layering to color mixing in the sense that the same area will be painted with a mix of different colors but instead of mixing them at the same time on the paper, you paint one, let it dry, paint another one, let it dry, and so on. This method is actually close to the printing process. Colors are separately applied and mixed on the paper.

THE TREE PLACE
Watercolor on paper mounted on board
Triptych, three pieces each 24" × 24" (61cm × 61cm)
In this painting, the background foliage has been painted mostly in a wet-on-wet technique. The tree trunks have been painted with many successive layers to obtain rich colors.

GETTING A NEW PERSPECTIVE
Watercolor on paper mounted on board
30" × 30" (76cm × 76cm)
The sky has been painted in successive layers of yellow, red and blue to obtain subtle variations in color.

What Else Should I Know About Layering?

Layering can be tricky. Here are a few things to watch for:
- To prevent your colors from getting muddy, be very careful not to lift the previous layer of color. Make sure the previous layer is totally dry before your next paint application, and use a soft brush with a light hand.
- Some colors are more intense than others. For example, when layering skin tones in my portraits, I start with a layer of yellow, then red and finally blue. That last layer of blue can easily overpower the colors beneath, so I use very light washes with the more intense colors.
- When layering colors, you are painting the same area repeatedly. That makes it difficult (if not impossible) to keep the edges sharp. Layering techniques usually produce edges that are not perfect. Some of the colors from previous layers will peek out. This is part of the charm of layering, and I think it adds interest to a painting.

Selecting Colors for Layering

When layering colors, you need to have an idea of how much of each of the layering colors you will need and where they will go. You can make an educated guess. For example, a bright orange will be mainly yellow and red and a more subdued orange will be mainly yellow and red with a tiny bit of blue. You can also use an image editing software like Corel PaintShop Pro® or Adobe Photoshop® to split the channels of your reference photo into CMYK (cyan, magenta, yellow and black). This will tell you how much of each primary you should use in each of your color mixes.

Here are a few other factors to consider when approximating colors for layering:

- How much yellow, red or blue comprise the local color? For example, an orange will be mainly red and yellow, a green will be blue and yellow.

- Is the color very bright or a bit subdued? If the color is subdued, then it has a bit of its complement in it. For example, a subdued red will have a bit of green in it.
- How intense is the color? The more intense, the more paint and less water you should use. A very bright orange will have more yellow and red than a light orange.
- Is the local color in shade? If it is, then it has a bit of its complement and a bit of blue mixed in.

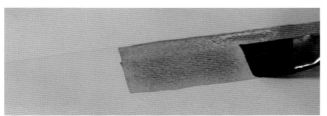

Layering an orange tone by painting a yellow layer and then a red layer.

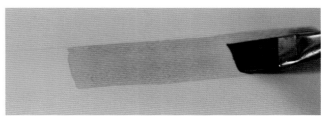

Layering a green tone by painting a yellow layer and then a blue layer.

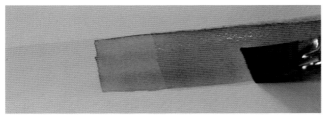

Shade on the orange tone: A light layer of blue tones down a bright orange.

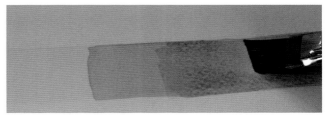

Shade on the green tone: A light layer of purplish-red tones down a green.

What is Local Color?

Local color is the natural color of the object you are painting, unmodified by light or shade. Let's say you are painting a red apple. Its shade might actually be a mix of red (its local color), green and blue.

DOWNLOAD IT! Make a Layered Color Wheel. Visit **ArtistsNetwork.com/ fearless-watercolor** to download a PDF exercise.

Recommended Colors for Layering Skin Tones

I generally try to have at least two go-to tones of yellow, red and blue: one cool and one warm. I decide which to use depending on the light temperature of the subject. A useful tip to remember is that shade on a warm color is usually cool and shade on a cool color is usually warm. Here are the colors I often use when painting portraits. They are also good general warm and cool color choices.

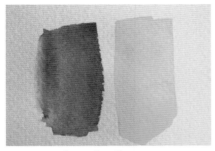

Warm and Cool Yellow Hues
The warmer hue is Yellow Ochre and the cooler hue is Cadmium Lemon Yellow.

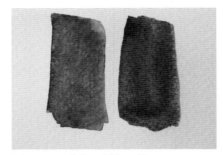

Warm and Cool Blue Hues
The warmer hue is Ultramarine Blue and the cooler hue is Prussian Blue.

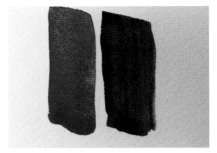

Warm and Cool Red Hues
The warmer hue is Permanent Red and the cooler hue is Alizarin Crimson.

In What Order Should the Colors Be Layered?

As a general rule, it makes more sense to layer the more opaque colors first and then to paint the transparent layers on top of the opaques. That way, all pigments will show through the layers and build up the new color.

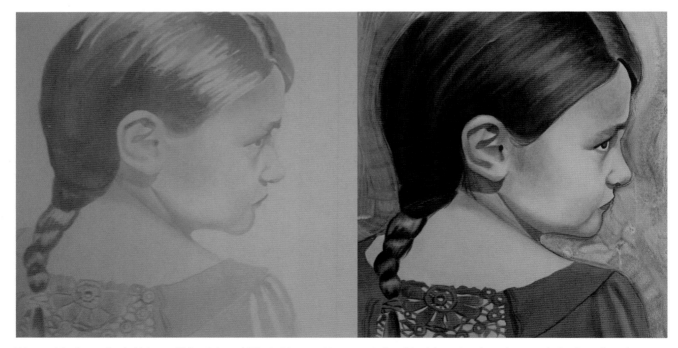

This portrait has been painted with layers of Yellow Ochre, red (Alizarin Crimson and Permanent Red) and blue (Ultramarine Blue and Prussian Blue). Yellow Ochre is the most opaque color, and the blue and red pigments used are more transparent. Therefore, the first layer to be applied was Yellow Ochre.

When Might I Use Layering?

Layering Transparent Watercolor to Build Up Skin Tones

The skin and hair colors have been created by layering the three primary colors: yellow, red and blue.

Layering to Render Atmospheric Effects

Layering can be an effective way to build up luminous colors that will render atmospheric effects. The layer of yellow-orange beneath the green buildings helps show the effect of light in this cityscape.

Layering to Paint Skin Colors

Layering works well in portraits, as it gives you more control over rendering skin tones; you can focus on tone and edges while slowly building up hues.

Glazing Colors

In essence, glazing is the same as layering, except it is usually done in a more transparent and subtle way with a goal of subtly modifying the underlying color. To glaze with watercolor, you will apply a light wash over all or part of a painting. You might glaze an entire painting if you want to add a bit of color harmony to the entire piece; it's a good way to connect disparate colors. You may also decide to glaze just a part of the painting. It's a great way to tone down a too-demanding color, for example. In such a case, you would add a glaze in a complementary color.

An orange color is toned down with a light complementary blue glaze.

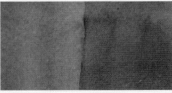

A bright blue is toned down with a complementary brown glaze.

A bright green is toned down with a light complementary red glaze.

PAINTING WITH MULTIPLE COLOR MIXING TECHNIQUES

Most paintings will be painted using a variety of these color mixing techniques: wet on wet, painting directly using colors mixed on the palette, and layering.

Here are three close-ups of the same painting (*Out of the Blue*). Different techniques have been used to paint this landscape: direct painting with flat colors, wet-on-wet painting and layering to develop textures.

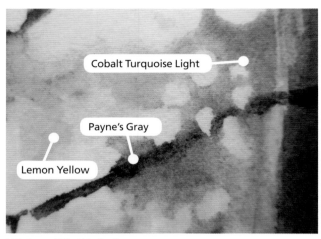

Cobalt Turquoise Light

Payne's Gray

Lemon Yellow

Wet-on-Wet Painting
Some of the foliage has been painted wet on wet; different tones of green and blue-green have been allowed to mix in a wet-on-wet manner.

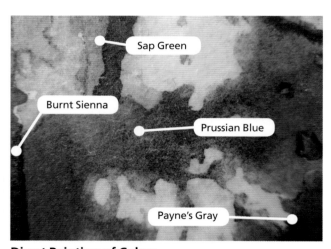

Sap Green

Burnt Sienna

Prussian Blue

Payne's Gray

Direct Painting of Colors
In this example, a few colors have been painted flat, next to each other, allowing hard edges to form.

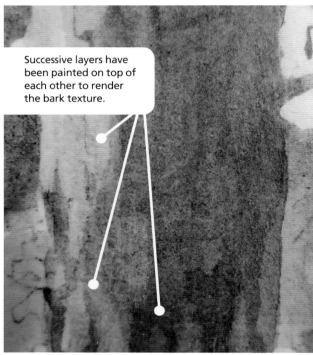

Successive layers have been painted on top of each other to render the bark texture.

Layering of Colors
To develop the bark's texture, several layers of color have been painted. Each of the successive washes dries in between.

Perfection is Overrated

Your artwork doesn't have to look perfect all the time; a bit of messiness can add interest. Having fun is the key. All the time. Enjoying the painting process will make you want to spend more time painting. Enjoying the process with keep you motivated and will help you build your skills.

The things that help you relax and enjoy the process will be different for everyone. I personally enjoy drinking a cup of tea and listening to French radio when painting. It helps me get in the zone.

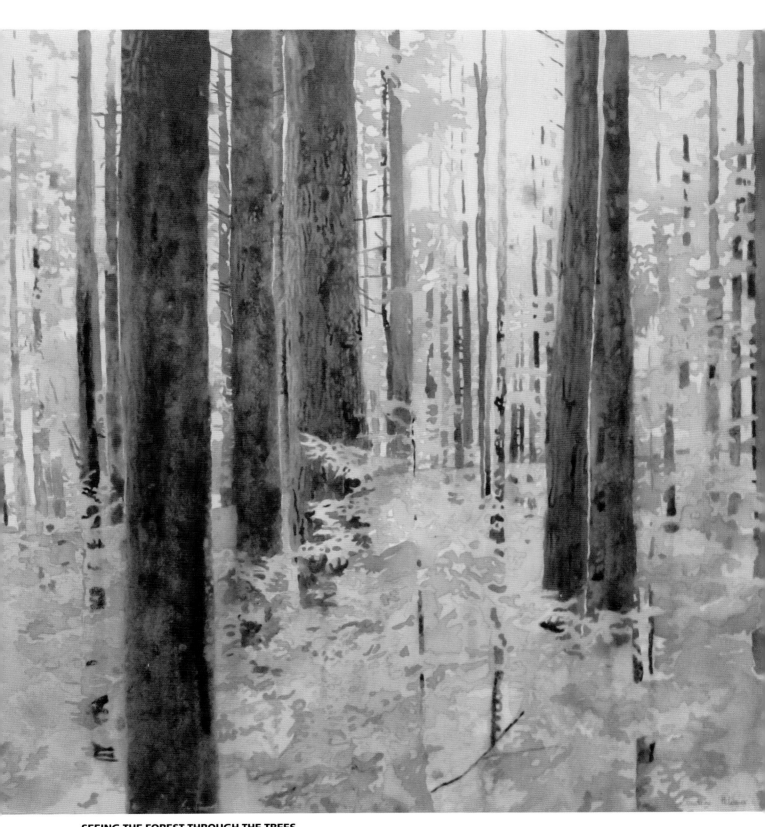

SEEING THE FOREST THROUGH THE TREES
Watercolor and mixed media on paper mounted on board
30" × 30" (76cm × 76cm)
Private collection

Paint Skin Tones Using a Layering Technique

If you don't use a layering technique to paint skin tones, you need to think about many different things simultaneously, including color hue, color tone and edges. It can become overwhelming.

If you layer the colors one after the other, you don't have to think about the color hue anymore because you are going to paint all the yellow first, then all the red and all the blue; you won't need to do any color mixing. When painting directly you must have the right color mix for every section. Because this is a difficult thing to do, you probably will not have time to pay attention to edges and details in tone.

Layering makes painting portraits more manageable because you focus only on tone and edge quality, and not on mixing the right hue.

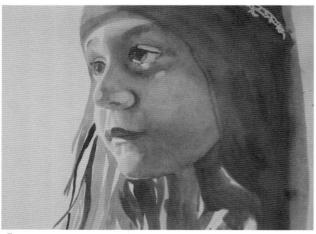

1 Paint Your First Layer
Use photo editing software to help you determine how much of each primary color you should use and where to place them. After you've finished your drawing and preserved some white areas with masking fluid, apply the first layer. Here I've used Yellow Ochre.

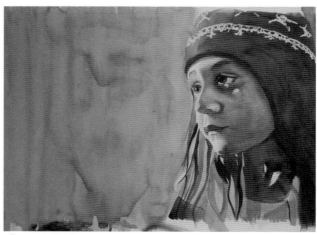

2 Paint Your Second Layer
The second layer is red. Consider painting your background in an irregular way; textures will develop and provide a more interesting effect than a perfect flat wash would.

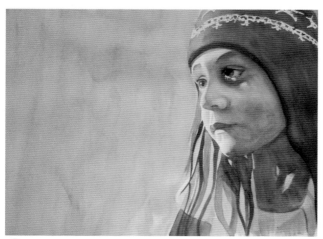

3 Paint Your Third Layer
The third layer is blue. Remember to use a very diluted blue wash, as it can easily overpower the other colors.

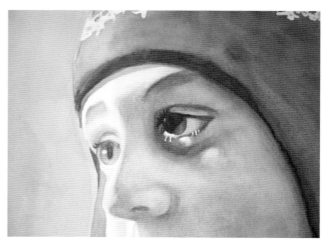

4 Continue Layering
Keep layering colors until you get the desired tone. When you are satisfied, remove the masking fluid and soften the edges with a bit of water and a stiff brush.

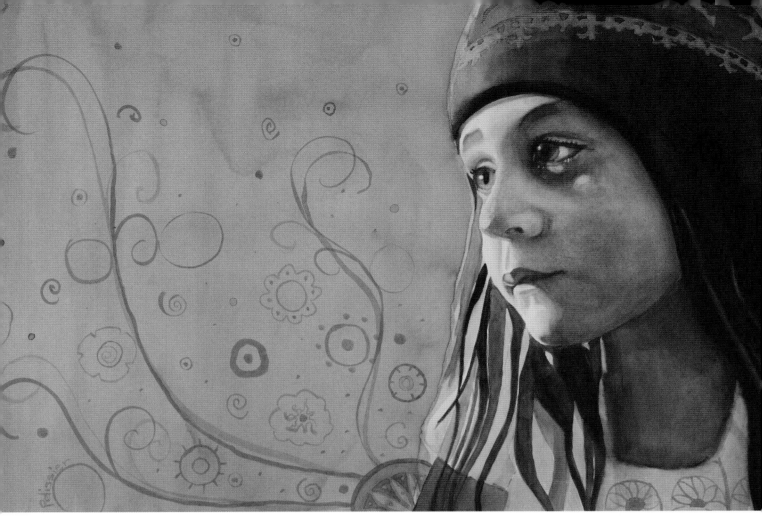

I WISH IT WOULD SNOW FLOWERS
Watercolor and mixed media on paper
15" × 22" (38cm × 56cm)
This painting, including the background, was painted in successive
layers of yellow, red and blue. Then I applied a layer of gouache mixed
with a bit of Turquoise Blue watercolor. (See *Chapter 5, Demonstration:
Painting a Background with Watercolor and Gouache*; I used ink in that
demonstration, but you can do the exact same thing with watercolor.)
The background was then reworked with watercolor pencils to add
flowery patterns. (See *Chapter 5, Demonstration: Drawing with
Watercolor Pencils*.)

WATCH IT! Watch Sandrine **Paint a
Portrait Using a Layering Technique**.
Visit **ArtistsNetwork.com/fearless-
watercolor**.

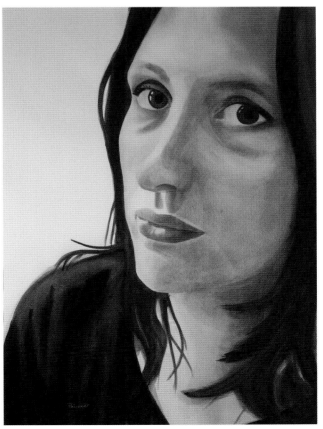

SOPHIE IN THE KITCHEN
Watercolor on paper
28" × 28" (71cm × 56cm)
Sophie in the Kitchen was painted with layered colors for the skin
tones. Sometimes you might need to adjust the colors you achieve with
the layering process. In this case, I lightened some of the darker colors
by scrubbing them off with a stiff brush and water. I wanted to keep
the portrait simple, almost minimalist, so the focus remained on the
face. This is also why I left the background unpainted.

Grisaille: A Layering Technique

Grisaille is a painting technique that has been used by many oil painting masters since the Renaissance. It is basically a technique for painting your subject in two steps.

First, you'll try to reproduce as accurately as possible the effects of light and shade within an underpainting of monochromatic or nearly monochromatic gray, brown or violet.

Then you will paint the local colors. Because of the first monochromatic layers, a flat wash will result in different tones of your color.

This technique can be successfully adapted to watercolor. You can try a gray, brown or violet underpainting. The most commonly used color for underpainting with watercolors is violet. Violet can be mixed so it will contain more red or more blue, and therefore, due to the transparent properties of those colors, will be invisible under most subsequent layers.

If you were painting a violet object, an underpainting in brown or gray would be a better choice.

In the following demonstration, you'll use the grisaille technique to paint a complex subject, marbles that show many variations in tones and hue as well as a variety of soft and hard edges. The advantage of this technique is that it simplifies the process of painting a complex subject. In the first stages, you only have to worry about light, shade and edges, and not color.

YOU WILL NEED:

Holbein Permanent Red and Da Vinci Ultramarine Blue for the violet

Da Vinci Cadmium Yellow

Da Vinci Cobalt Blue

Da Vinci Prussian Blue

Da Vinci Sap Green

Yarka Emerald Green

Holbein Permanent Alizarin Crimson

Other materials:

Assortment of brushes

Masking fluid and silicone brush

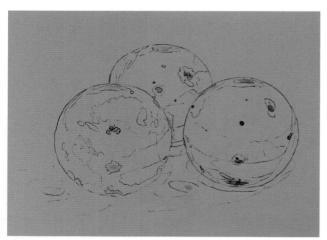

1 Transfer Drawing and Mask as Desired
After transferring your drawing to watercolor paper, preserve a few white highlights with masking fluid. You can apply the masking fluid while your drawing is still on the light box so you can clearly see where those preserved white areas should go.

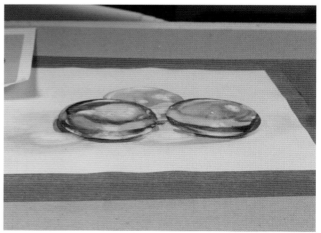

2 Paint Your Base Layer
Painting the monochromatic layer is easier if you can look at a black-and-white reference photograph of your subject. The violet used here is a mix of Permanent Red and Prussian Blue. Paint the marbles wet on wet if you want soft edges or wet on dry if you want hard edges. (For more on edges, see *Chapter 3, The Importance of Edges.*)

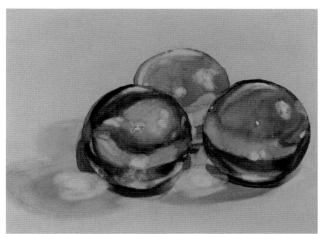

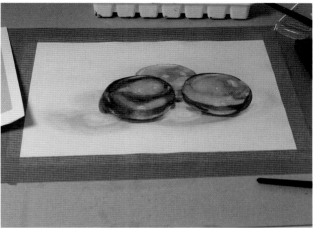

3 Continue Layering

Keep painting layers until you have achieved the desired level of contrast. Ultimately you want an array of tones from white to very dark violet. Let the monochromatic layer dry thoroughly. Drying will take a few hours.

4 Add Local Colors

When painting the local colors, be careful not to disturb the previous layers. Use a soft brush with a light hand and pay attention to your hue changes. You don't need these layers to be very dark for this step because you already have a dark layer of paint—violet—on your paper. You can start with a wash that is light in color; use the same light color you see in the lightest areas of your object. Remember, all the successive layers on your paper are building up to make the final color. So let's say you are painting dark blue on a shaded area of an object. You paint an extra layer if at any point you feel your color is too light.

5 Make Final Adjustments

Remove masking fluid and make any final adjustments. The white areas left by the masking fluid will probably need their edges softened with a stiff brush and water. You can also adjust colors at this stage. Lift up a bit of paint if you want to lighten any areas.

Painting a Forest with a Layering Technique

What is the difference between grisaille, layering and glazing? Basically all three terms describe painting successive layers or washes of semitransparent paint. In the grisaille technique, the first layers will be monochromatic—usually violet, gray or brown—and the tones will be fully developed. The last layers are light layers of local color. And while *layering* and *glazing* are essentially synonyms, glazing is more frequently used to add one layer of semitransparent paint over another color, while layering is more frequently used to build up multiple layers of paint.

In this demonstration, we will mix brown tones directly on the paper by layering yellow, red and blue.

YOU WILL NEED:

Cobalt Turquoise Light

Permanent Red

Burnt Sienna

Prussian Blue

Cadmium Lemon Yellow

Sap Green

Rembrandt Medium Yellow

Rembrandt Madder Lake Light

Rembrandt Payne's Gray

Other materials:

Assortment of brushes

Gouache

Masking fluid and silicone brush

1 Paint Foliage and Add Yellow Layers
After the foliage has been painted by allowing colors to mix wet on wet, paint the trunks with the first layers of Medium Yellow. Be careful to leave the upper part of the painting lighter in color.

2 Add Blue Layers
After the previous layer has thoroughly dried, add layers of Prussian Blue. Again, be sure to leave the upper part of the painting lighter in color.

3 Add Red Layers
Layer on red paint, again ensuring the upper part of the painting is lighter.

4 Splatter Various Mixes Over the Painting
Splatter the painting with different mixes of watercolor and water, and watercolor, gouache and water.

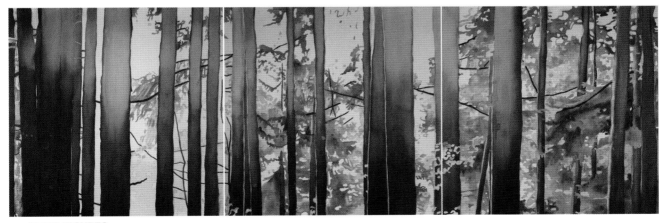

STICK FIGURES
Watercolor and mixed media on paper mounted on board
Triptych, three pieces each 24" × 24" (61cm × 61cm)
Private collection

FOREST LANDSCAPES PALETTE

The palette used in this demonstration is a good palette to consider for painting forest landscapes.

THE IMPORTANCE OF EDGES

When planning a painting, it is helpful if you know where the limits (or *edges*) of your wash are and if you want them to be hard or soft. A hard edge is an edge with a very well-defined limit, and it's the kind of edge you get when you paint wet on dry. A soft edge has a blurry or graded limit and is the kind of edge you get when you paint wet on wet.

TREES OF RIVERBANKS
Watercolor on paper mounted on board
30" × 24" (76cm × 61cm)
This painting shows a variety of edges. For example, most of the edges inside the tree trunks are soft, so the trunks appear cylindrical. Most of the edges around the foreground leaves are crisp, so the leaves are easily differentiated from the background. Objects with sharper edges will appear to be more in focus than objects with soft edges; that's why backgrounds are often painted wet on wet with softer edges.

How Do Edges Work? What Do They Do?

Soft edges make an object appear round, and hard edges typically define the intersection between two plane surfaces.

Soft edges are especially important in portrait painting; too many hard edges in a portrait will give it a harsh, unnatural appearance.

A round object will have mainly soft edges. If you paint on wet paper, you will get soft edges. The wetter the paper, the softer the edges.

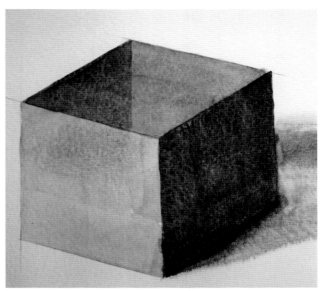

The intersections of plane surfaces will consist mostly of hard edges. If you paint on dry paper, you will get hard edges.

The edges that are created as a result of using masking fluid tend to be very hard.

Soften hard edges with a stiff brush and water. These softer edges make your painting look more natural.

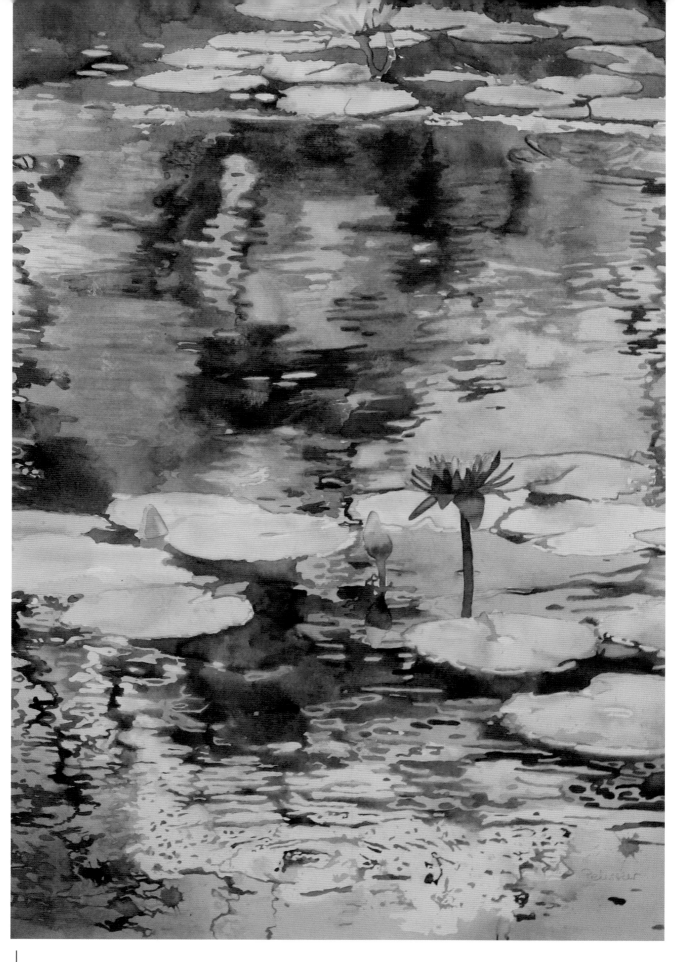

How Can I Soften a Hard Edge While the Paint is Still Wet?

If you want to soften a hard edge while the paint is still wet, prepare at least two brushes, one a recipient for the paint mix and the other a recipient for clean water.

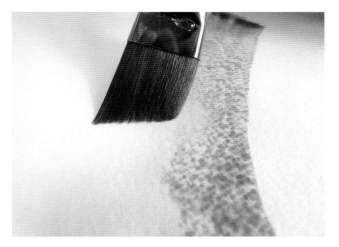

While the paint is still wet, go over the edge you want to soften with a damp brush. Deposit just enough water so the pigment is encouraged to move toward the water. Too much water will cause an irregular edge to form.

How Can I Soften a Hard Edge When the Paint is Dry?

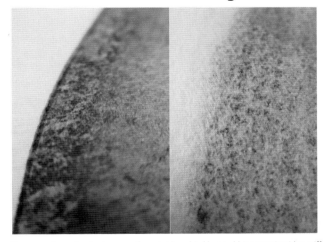

You can soften a hard edge once the paint has dried by scrubbing over it with a stiff brush and a bit of water.

Prevent Peeling Paper

It all comes down to quality. Some papers, especially student-quality papers, are more likely to peel than others. I personally prefer and trust Arches paper. It can withstand quite a bit of scrubbing without peeling.

NYMPH ECHO
Watercolor on paper
29" × 17" (74cm × 43cm)
Private collection

Blurry Background and Sharp Focal Point

With a still life you can paint the background on wet paper and your focal point on dry paper, thereby replicating a much-loved photographic style.

1 Prepare Drawing and Wet the Paper

Use a pencil to create your drawing, and then mask any objects that should not be painted when the background is painted. In this example, I've covered whole berries with masking fluid. Use a big soft brush to wet your whole paper with clean water.

2 Paint the Background

Paint your background in a wet-on-wet manner; the colors will spread a bit and form soft edges.

3 Lift Color as Desired

You can carve out lighter areas with a tissue.

4 Continue to Lift Color

Use a dry or "thirsty" brush to lift color in a more detailed manner. Allow the background to dry.

5 Paint Focal Point

Remove the masking fluid. Paint your main subject using a wet-on-dry technique.

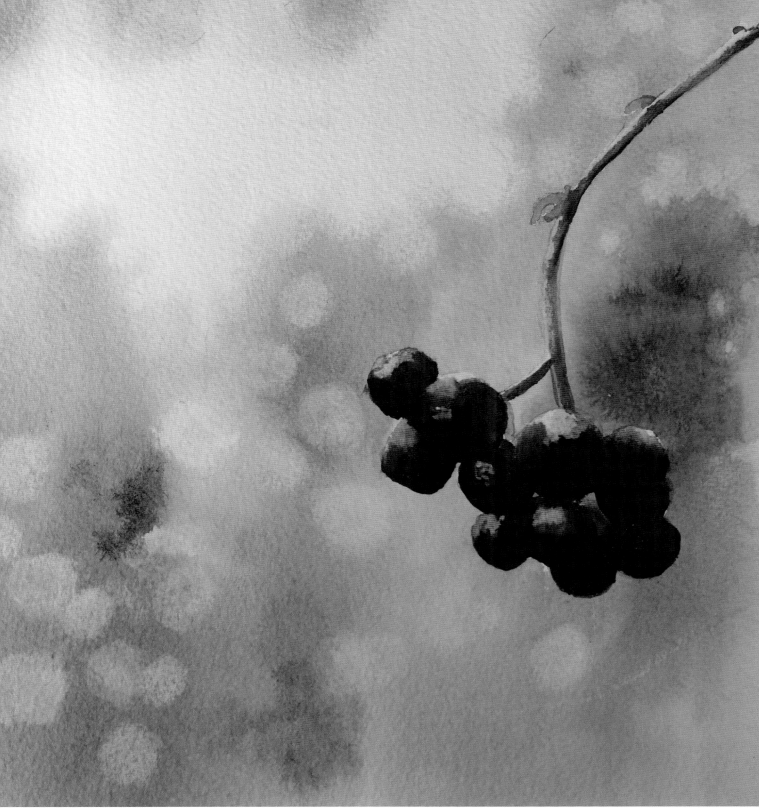

BERRIES (DETAIL)
The background has been painted with soft edges, replicating a photographic effect.

WATCH IT! Watch Sandrine **Paint a Focal Point as a Wet-on-Wet Wash Dries.** Visit **ArtistsNetwork.com/fearless-watercolor.**

Paint a Soft-Focus Portrait

When painting a portrait, you can paint most of the skin and hair wet on wet so your edges are soft. Use hard, more defined edges for the features, as I did in this simple self-portrait.

1 Paint First Layers
Your base layers should be painted mostly in a wet-on-wet technique. Start with your lightest colors. Be sure to preserve white areas (like the whites of the eyes) with masking fluid.

2 Add Dark Layers for Hair and Shadows
Add your darkest colors now, continuing to work wet on wet and keeping your edges soft.

3 Paint the Facial Features
Paint the facial features wet on dry to ensure definition. Allow all the paint to dry.

4 Finish the Portrait
Remove the masking fluid and soften any resulting harsh edges by scrubbing softly with a stiff brush and water. Paint the background of your portrait as desired. (My background is painted directly with areas of color applied wet on dry.)

CLICK IT! Visit **ArtistsNetwork.com/fearless-watercolor** for **Tips for Successful and Satisfying Portrait Painting.**

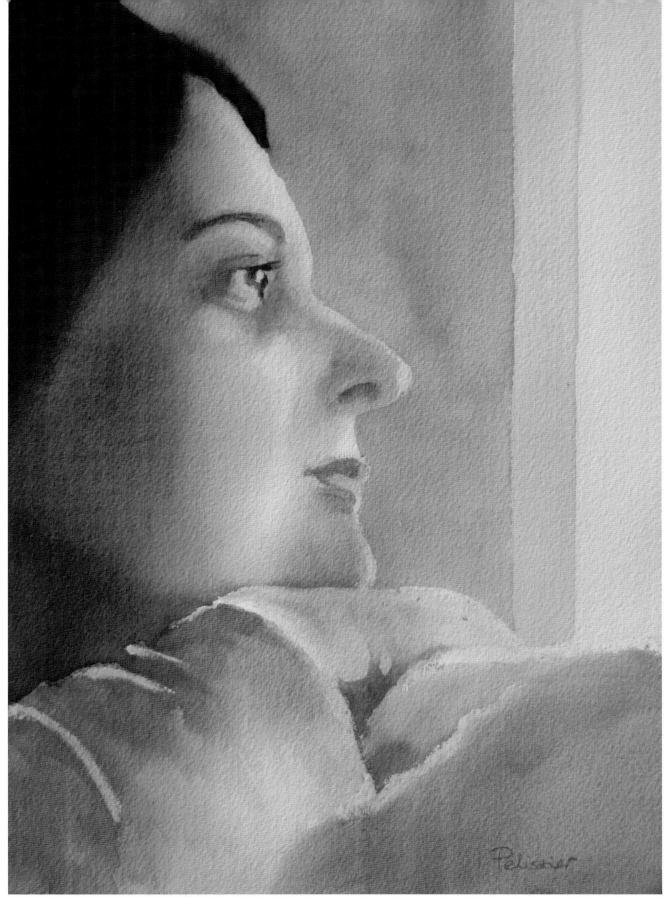

SELF PORTRAIT AT THE WINDOW
Watercolor on paper
11" × 9" (28cm × 23cm)

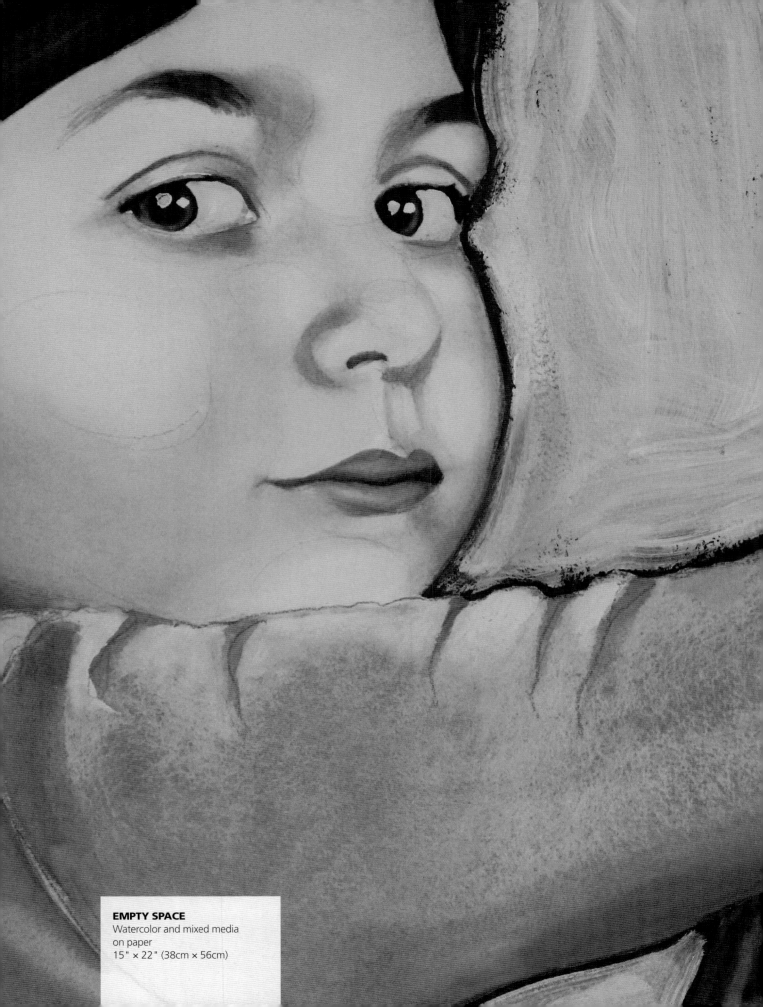

EMPTY SPACE
Watercolor and mixed media
on paper
15" × 22" (38cm × 56cm)

Techniques for Adding Texture

SPLATTERS, DRIPS AND DROPS

I like the imperfections of the watercolor medium and am frequently looking for ways to add more imperfections to my paintings. I guess you could say I'm a thrill junkie! I enjoy the feeling I get from possibly messing up something I created.

Most of the time, though, I am pleased with the results I see as a result of splattering and adding drips and drops to my work.

Splattering Tools

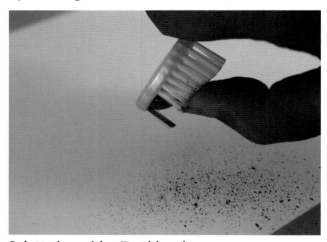

Splattering with a Toothbrush
A toothbrush is a fun tool to use to splatter. It produces fine splatters and gives you control over the direction of those splatters.

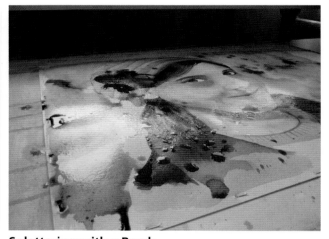

Splattering with a Brush
A brush can also be used to splatter paint. The resulting drops will be larger than with a toothbrush.

Splattering with an Eyedropper
An eyedropper allows you to control exactly where you place the drops.

A LITTLE BIRDIE TOLD ME (DETAIL)
Drips have been splattered around the red bird.

FREIGHTERS
Watercolor on paper
15" × 22" (38cm × 56cm)
This watercolor painting of a freighter has
been splattered with water and watercolor
paint to give it a wet, textured look.

Make It Messy By Adding Splatters

You can add splatters directly while painting or you can try this technique on a finished painting. In this example, I first painted the foliage wet on wet, and then watercolors were layered on the trunks. Once the trees were painted, I decided to add a bit of unpredictability, texture and interest by adding drips and splatters.

1 Mix Gouache with Water
Mix white gouache with water to make a semitransparent white mix that will show over watercolor without overpowering the rest of the painting.

2 Apply Gouache Mix
You can apply the gouache mix randomly with an eyedropper or by dipping a brush in the mix and flicking the paint onto your painting.

3 Layer Splattering
Add more splattering. Here I splattered some green watercolor after the white splatters dried.

4 Continue to Splatter
Continue to splatter gouache mixes and watercolors until you are satisfied with the look you have achieved. You don't want the splattered colors to mix. Let each layer dry before adding another.

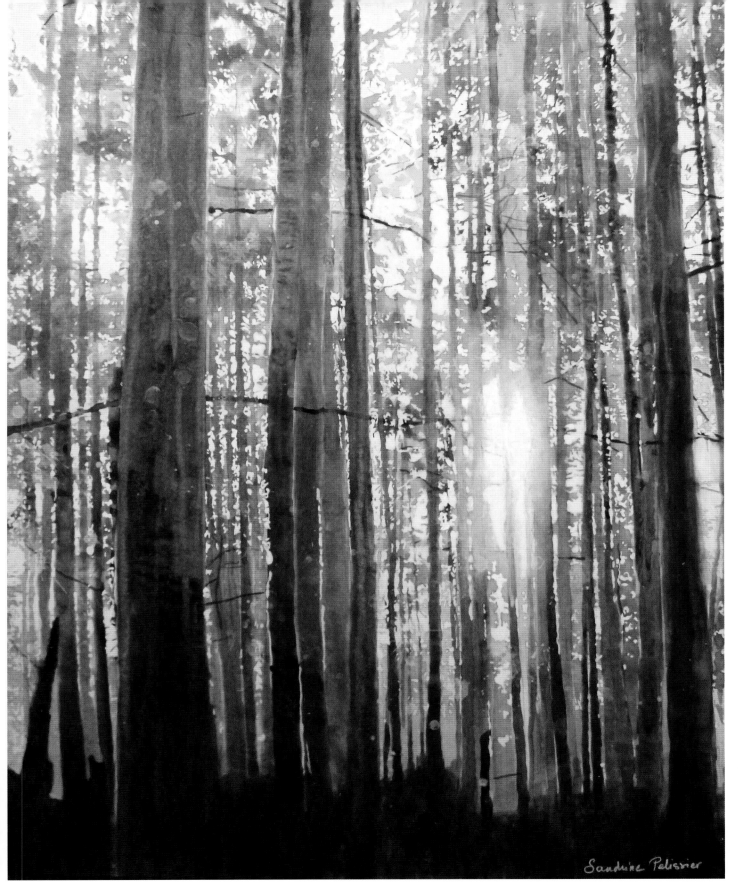

PRINCESS PARK
Watercolor on paper mounted on board
30" × 24" (76cm × 61cm)
Private collection

SALT TEXTURES

Salt applied to a wet wash will produce textures by pulling the water and pigment into the salt crystals, which results in lighter areas around the salt crystals.

The textures will look different depending on the size of the crystals. Coarse salt will produce the most obvious texture. This is a fun and easy technique for adding interest to a painting. If you want your paper to maintain its archival properties,

though, I wouldn't recommend using salt on a wet wash as it may damage the fibers of the paper in the long-term. There are no archival concerns using salt techniques with Yupo paper, since Yupo is technically a plastic.

To produce salt textures, sprinkle salt on a wet wash at the point in time when it is just beginning to lose its shine. Brush the salt away once the wash has dried thoroughly.

Fine Salt on a Wash
The texture is more subtle with fine salt.

Coarse Salt on a Wet Wash
The texture is more obvious.

Salt on Yupo Paper
Salt textures will show very well on Yupo paper.

A Word of Caution

You can easily get carried away with salt textures, so I recommend using them sparingly. The goal is to blend them in well with the rest of the painting.

When Might I Want to Use Salt Textures?

Salt texture works well when you want to represent anything grainy, like old walls, pavement, sand, rocks, dirt, granulation and abstract backgrounds. I would not use this technique for skies, as they usually have a more ethereal than granulated feel.

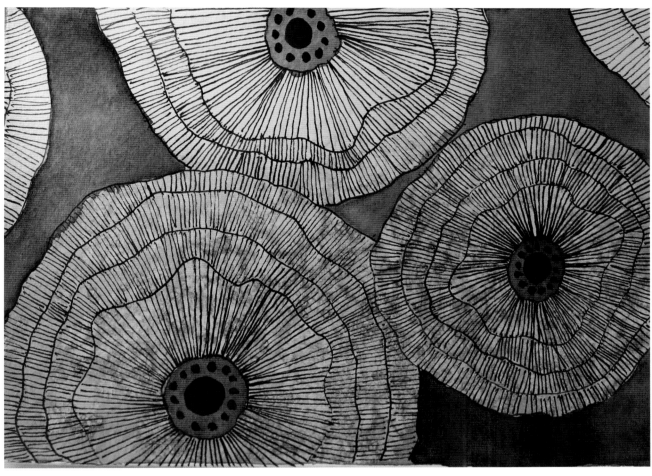

POPPIES 3
Mixed media on watercolor paper
4" × 6" (10cm × 15cm)
Textures are always interesting in a background that surrounds designs like Zentangles® patterns or doodles. In this example, I used a salt-textured background as a base for flowers drawn with black markers.

Rice: An Alternative to Salt

Rice can be used as a safe alternative to salt (it won't damage your paper). The texture will be bigger, of course. As with salt, just drop the rice grains on a wet watercolor wash and leave them until the paint is dry.

Paint a Cityscape with Salt Texture

Salt can be used to add texture in a variety of ways in your paintings. Here it is used on a rainy sidewalk in a Vancouver cityscape.

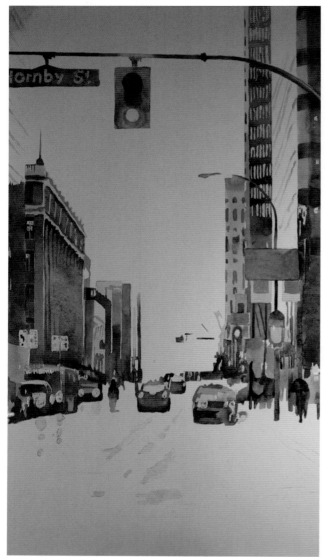

2 Paint Sidewalk and Street and Add Salt
Sprinkle coarse salt on the wash once most of the shine is gone. (To see if the shine is gone, look at the painting at an angle to the light.)

1 Paint a Simple Cityscape
After transferring an outline of your scene onto paper, paint the subjects using wet-on-wet and layering techniques. Preserve desired areas with masking fluid so they will be easier to paint around. Let the paint dry.

(Leave the sidewalk and street unpainted for now. It will be painted with a wet-on-wet wash in which the colors of the reflections under the lights of the cars will be added.)

3 Brush Off Salt Crystals
Once the wash has dried, brush off the crystals with a large clean brush. You can layer several washes with salt if you are looking for a more complicated texture.

VANCOUVER BLUES
Watercolor and watercolor crayons on paper
25" × 15" (63cm × 38cm)
This painting has been finished with watercolor crayons and splashed with water so the salt
textures blend in with the overall painting.

HOW TO PAINT WITH A DRY BRUSH

Drybrushing is a technique that builds up textures and colors gradually. To paint with a dry brush, you need to apply paint on your brush with very little water and then rub that dry brush against your paper. The peaks of the paper will pick up the pigments but not the valleys, so the texture of your paper will influence how the drybrushing looks.

Drybrushing will work better on regular paper than on Yupo paper. The paper needs a bit of tooth to pick up the pigments from the brush, and Yupo paper is too slick.

What Does It Work Well For?

I like to use the drybrush technique to add details, like hair on a portrait, the effect of light reflected on the surface of water, or to subtly increase the contrast in select areas of a painting. Some watercolor painters are very successful at applying this technique to slowly build up colors on a whole painting. It might work for you if you are not too attached to the free-flowing quality of the experience of painting with watercolor.

Drybrush Technique Close-Up
In this example, a dry brush technique is used to add contrast (by way of a dark brown paint) to the trees on the horizon.

Drybrush in a Painting
The drybrush technique has been used in the light reflection on the water to get a shimmering effect.

A BIRD'S EYE VIEW OF LOUISE
Watercolor and mixed media on paper
26" × 26" (66cm × 66cm)
This is a mixed-media portrait of my daughter. The face was painted by
layering colors (see *Chapter 3, Demonstration: Paint Skin Tones Using a
Layering Technique*), and then I added mixed media in the background
(acrylic and pastel contouring). Hair can be tricky to paint in a realistic
manner with watercolor; a drybrush technique is a good option because
you can render the fine texture of hair with greater control.

CUTOUT WAX-PAPER SHAPES

Cutout wax-paper shapes can be placed on a wet wash and left there until the wash dries. The shapes will leave a faint imprint on the wash. This technique works well on regular paper and Yupo paper.

Wax-Paper Shapes as a Resist
Place cutout wax-paper shapes on a wet watercolor wash.

Leave the Shapes in Place Until the Wash is Dry
Later in the painting process, you might consider outlining those shapes with watercolor crayon and painting the inside of each shape white to make them more visible on the finished painting.

Cutout Wax-Paper Shapes on Regular Paper

Cutout Wax-Paper Shapes on Yupo Paper

Thread on Yupo Paper
Other materials laid down on a wet wash will also leave traces that can make interesting textures. Here a thread is placed on a wet wash on Yupo paper.

Thread on Yupo Paper
Once dried, the thread is removed. It leaves behind an interesting texture.

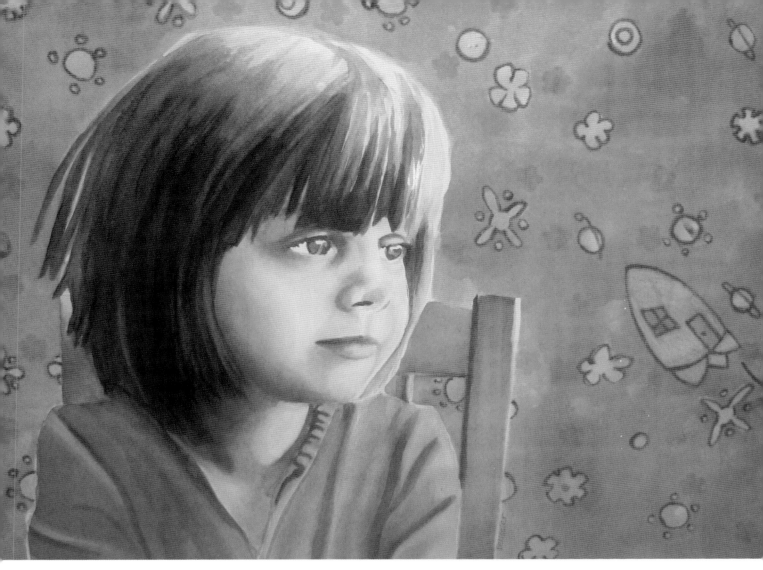

**FROM NOW ON YOU CAN CALL ME
NEIL ARMSTRONG**
Watercolor and mixed media on paper
15" × 22" (38cm × 56cm)

RYAN-JI
Watercolor and marker on Yupo paper
9" × 11" (23cm × 28cm)

ALCOHOL AND WATER TEXTURES

Alcohol and clean water can make very striking textures on a wet wash, since they disperse the paint in the area to which they have been added. The effect is more subtle with water than with alcohol, and you get a fish-eye effect (a darker area in the center of the lighter area) with alcohol that you won't get with water.

When dropping water onto a wet wash, you are intentionally producing back runs.

A drop of water on a wet wash will cause the paint pigments to move away. The trick here is to drop the water when your wash is almost dry. If you do it when the wash is still very wet, the paint pigments will rapidly remix and the texture will disappear.

In this example, drops of alcohol have been added to a wet wash. The alcohol has repelled the paint, leaving a slightly darker area (or fish-eye effect) in the center.

Drops of alcohol on a Yupo paper wet wash will produce very visible textures.

Drops of water on a Yupo paper wet wash will also produce visible textures. This technique works better if the wash is not too wet; if it is, the paint will likely remix.

Will Alcohol Ruin My Paper?

Rubbing alcohol is slightly acidic but very close to a neutral pH, so it won't change the pH of your acid-free paper.

ENGLISH GARDEN
Watercolor and mixed media on canvas
12" × 12" (30cm × 30cm)
This painting on canvas was built up of
watercolor textures made with drops
of alcohol on a wet wash. Once the
background had time to dry, I looked for
shapes in the abstract patterns and came up
with this floral still life.

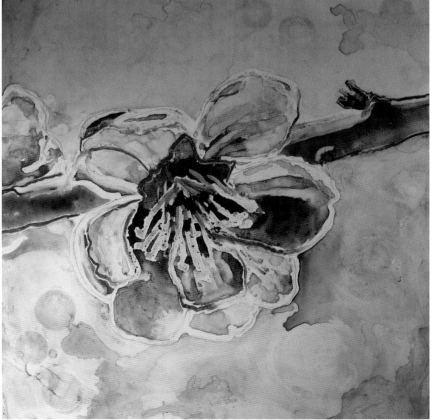

CHERRY BLOSSOM 2
Watercolor and oil pastels on Yupo paper
10" × 8½" (25cm × 22cm)
The textures in the background of this Yupo
paper floral painting have been created by
dropping alcohol on the still-wet wash.

SCRATCHING OFF PAINT

Scratching off watercolor paint while it is still wet works well for representing grass, for example, or for carving out tiny branches for a tree. You can use a variety of tools to do so, as long as you are careful not to make a hole in your paper. Tools you might consider include a painting knife, the corner of a plastic card (like a hotel room key card or credit card) and the handle of a brush. The options are limitless.

And while these tools can be used to remove paint from a wet wash, they can also be used to add marks by dipping them first in paint (a technique called *sgraffito*).

Scratching Paint Off Paper
While the paint was still wet, I removed paint using a painting knife to carve out lighter branches.

Scratching Paint Off Yupo Paper
You can use this same technique on Yupo paper. Here I've used it to evoke the texture of wheat fields.

Help! I've Made a Hole in My Paper!

Hey, it happens. Sometimes you may be too rough while scrubbing with a stiff brush, or while using a razor or a painting knife.

You have different options depending on the size of the tear. If the tear is big, the easiest way to repair it is to attach another piece of paper to the back of your painting with acrylic medium. Try to blend the new paper into the old as much as you can.

If the tear is smaller, it might be possible to close it by filling it from the back side of the paper with a bit of gel medium.

Another option is to paint a layer of white acrylic gesso over the tear and then repaint the area of the painting that was damaged.

It is also possible to add a layer of tissue paper or rice paper collage and paint over it to seal or disguise the tear.

DOWNLOAD IT! Visit **ArtistsNetwork.com/fearless-watercolor** for a downloadable PDF: **Fixing Mistakes and Lifting Color**. Sandrine shares techniques for fixing what you might not like in your work.

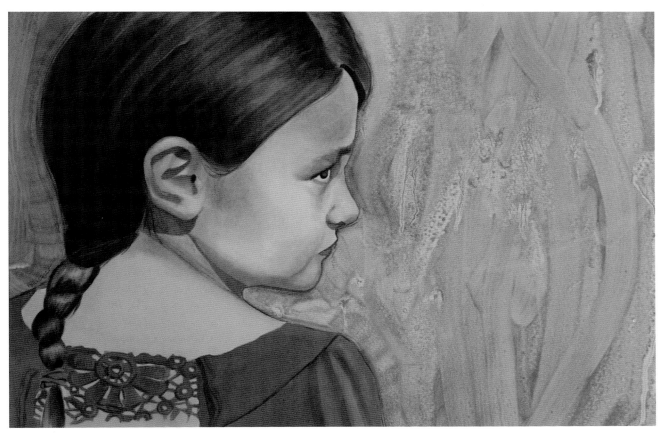

THEY KEEP ME COMPANY
Watercolor and mixed media on paper mounted on board
15" × 22" (38cm × 56cm)

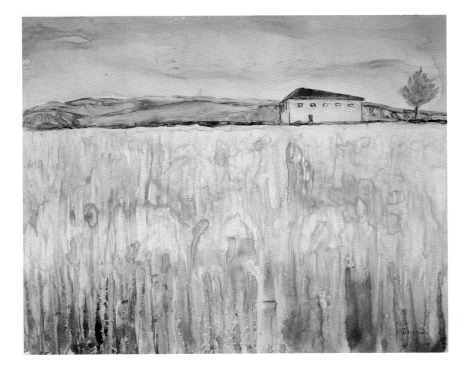

WHEAT FIELDS
Watercolor on Yupo paper
9" × 10" (23cm × 25cm)

WAX RESIST

Wax resist is a technique that can be used on Yupo paper and regular paper. A wax resist will have a more textured look than a masking fluid resist because wax (such as oil pastel) is picked up by the texture on the paper. The edges along a wax resist will also be textured and softer than what you usually get with masking fluid.

It should also be noted that when using masking fluid, you have the option of painting the resulting white areas that have been preserved. That's not an option when using wax as a resist; the wax will repel paint if you try to paint over it.

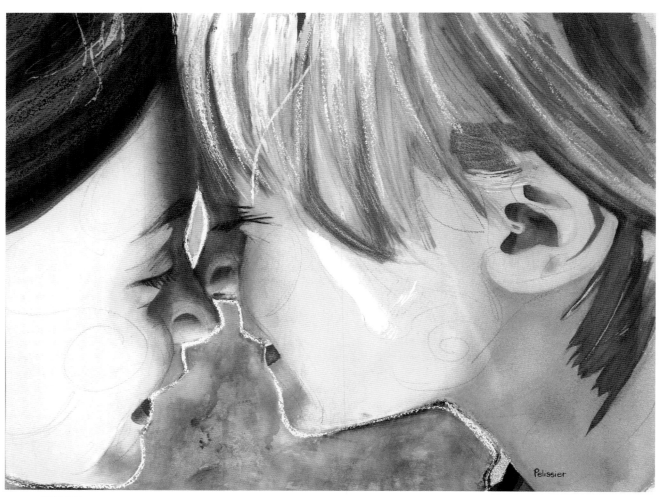

SISTERS
Watercolor and mixed media on paper
22" × 28" (56cm × 71cm)
In this painting, white oil pastels have been used as one would use masking fluid to preserve highlights in the hair.

Will the Wax Stay on My Paper?

Wax (and anything oil based) will repel paint, so it is an easy way to preserve some lighter (or white) areas from being painted. The main difference between wax and masking fluid is that you can peel off the masking fluid; crayon or oil pastel will remain in your finished painting. This is something to consider if you plan to apply a varnish to your painting. If so, you would need to use a varnish suitable for water-based *and* oil-based paintings.

Wax Resist on Yupo Paper

One common problem with Yupo paper is that its slick surface offers little control with the paint; the paint moves fast and won't stay where you are trying to put it. One way to gain a bit more control over the paint's movement is to draw outlines with wax crayons, outlines that will contain the watercolor where you want it. It's a bonus that a visible crayon outline adds a really interesting and unique look. If you prefer to not see the outlines, just use a white crayon. (You get similar results with oil pastels.)

1 Draw and Trace Your Image

Draw your image on the Yupo paper with pencil, so you can make corrections and adjustments before you add the wax. Then trace over all or some of the drawing with oil pastel or crayon. In this project I'm using a single color of oil pastel, but you can choose to use as many colors as you desire.

2 Paint

Paint each part of the painting as you usually would. I chose to mix several colors wet on wet.

3 Continue Painting

Paint right up to the resist lines. The wax from the pastels or crayons will contain the paint and prevent your washes from mixing.

WATCH IT! Watch Sandrine **Paint Using the Wax Resist on Yupo Technique**. Visit ArtistsNetwork.com/fearless-watercolor.

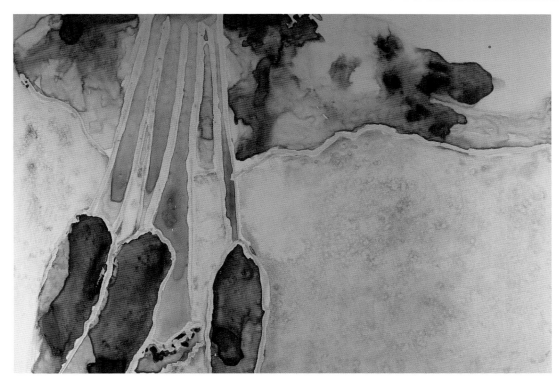

LILY FLOWER
Watercolor and wax
crayon on Yupo paper
9" × 11"
(23cm × 28cm)

BACK RUNS

Back runs occur when you add water to a freshly painted wash, either by touching a water-loaded brush to the wash or dropping water onto the wash. Back runs are also a product of the drop of paint that may sit on the edge of the paper. As the wash begins to dry, that drop of paint might form a back run. Adding fresh water will repel the paint and cause textures to form that sometimes look like flowers. Hence, their other name, *blooms*.

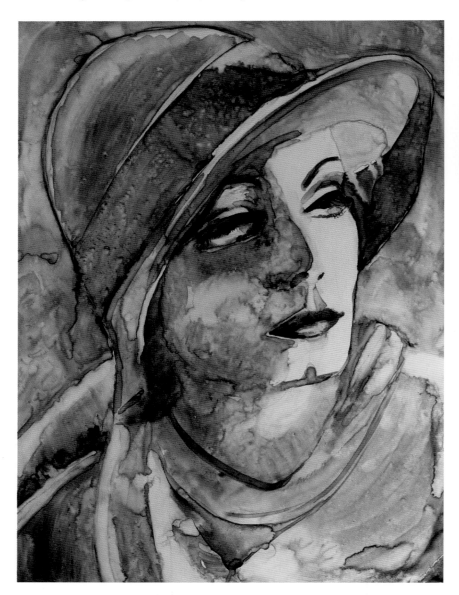

Back runs can add textural interest to a painting. This detail is from the right edge of the subject's shirt.

GRETA
Watercolor on Yupo paper
14" × 10" (36cm × 25cm)
(Painted from a photo of the great Greta Garbo.)

The Charm of Back Runs

Like drips, drops and uneven washes, I think back runs add to the charm of watercolor. You can avoid them by watching the borders of your washes and removing excess paint that might otherwise form a back run. You can choose to embrace the imperfection of the watercolor medium and try to make the most of happy accidents when they happen. You can also create back runs on purpose, which is as easy as splattering a still wet or not totally dry painting with water.

PLASTIC WRAP

Plastic wrap, when applied to a wet wash, will cause the paint to move and accumulate on the edges of wrinkles formed in the plastic wrap. Allow paper that's covered in plastic wrap to dry undisturbed, and you will be rewarded with an interesting geometric-looking texture. I like to use this texture as the base layer for paintings with mixed media and patterns drawn with markers.

Apply plastic wrap over a wet wash on regular paper and allow the wash to dry completely.

Use the resulting textured layer as a starting point to build up designs and patterns.

Apply plastic wrap over a wet wash on Yupo paper and allow the wash to dry completely.

Use the resulting textured layer as a starting point to build up designs and patterns.

SOAP

Soap added to paint will yield different results on regular paper than on Yupo paper.

On regular paper, soap will make the watercolor paint a bit thicker. Your colors will move more slowly on the paper, giving you greater control.

On Yupo paper, soap is very useful. You might notice that sometimes paint is unexpectedly repelled in certain areas. This is usually because of fingerprints on the Yupo. Adding a bit of soap to your water or paint will allow you to eliminate these paint-repellent areas. Adding more soap to Yupo paper will cause the paint to form tiny bubbles that will imprint texture in your wash once dry.

Soap on Yupo paper creates tiny bubbles that will be visible even after the wash dries.

Soap mixed with paint on regular paper makes the paint thicker, and pigments move more slowly than if you were just using water.

A Word of Caution About Using Textures

Textures are a lot of fun, but it's easy to get carried away and overdo them.

Of course, it all depends on your personal taste and what your painting is about. If your painting is about texture, then feel free to go crazy.

When painting texture onto an object, you often don't have to paint the texture on the entire surface of that object. Texture is usually more visible on the edges and in the places where the light is changing (on the edge of an area of light and shade, for example). If you think about fur on an animal, for instance, you might see more clearly the texture of the fur on the contour of the animal and in the light/shade contours, but not necessarily everywhere.

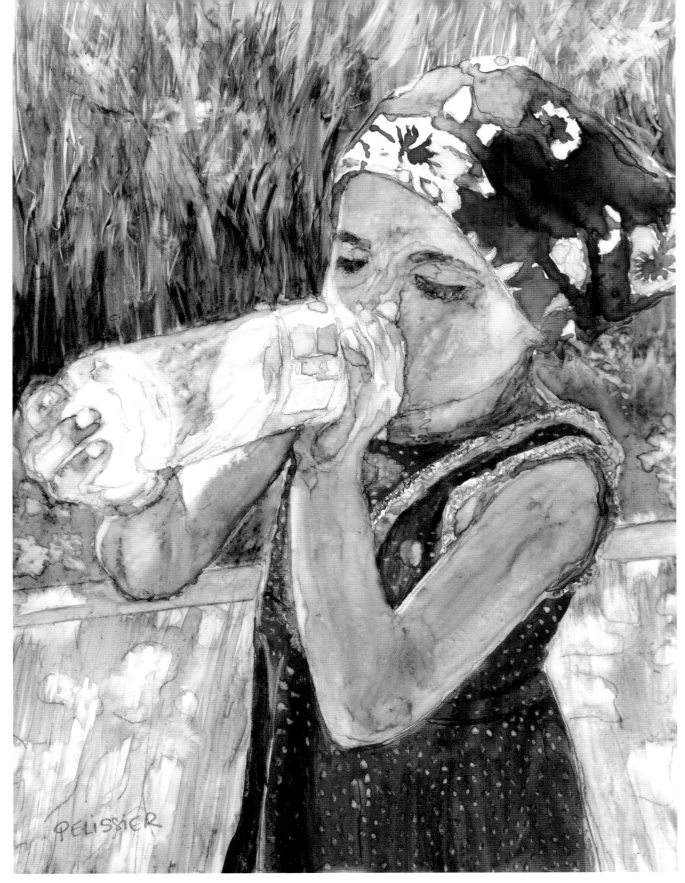

JUSTE AVANT L'ESCALADE
Watercolor on Yupo paper
11" × 9" (28cm × 23cm)
Private collection

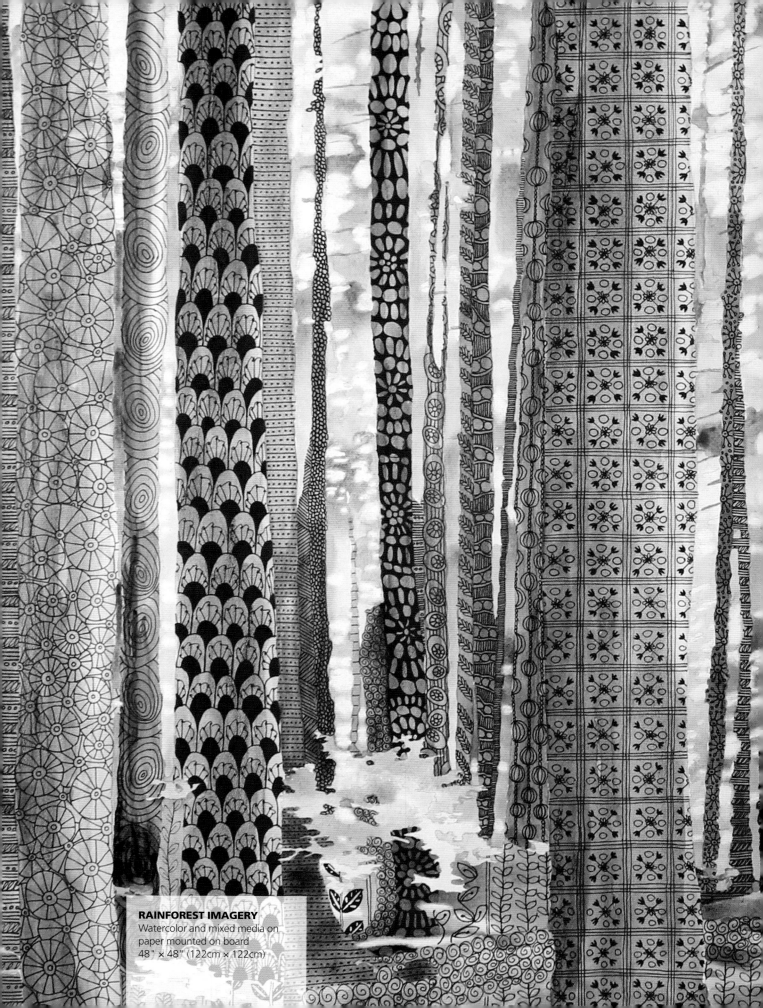

RAINFOREST IMAGERY
Watercolor and mixed media on
paper mounted on board
48" × 48" (122cm × 122cm)

Incorporating Mixed Media

BREAKING THE RULES AND HAVING FUN

Mixing media can be lots of fun, and there are many techniques and mediums you can try that will work well with watercolors.

As a general rule, you can layer and mix many different media as long as the water-based media are under the oil-based media. For example, oil pastel on top of acrylic or watercolor will work, but acrylic or watercolor on top of oil pastel will not. Adhesion and drying problems can arise in general when painting with a water-based medium on top of an oil-based medium. The water-based medium can't adhere properly to the paper because the oil-based medium is acting as a barrier or a resist between the paper and the water-based medium. The layer of water-based medium could peel off the oil-based medium. The paint could also crack when dry.

Another property to consider is water solubility. Does the medium you are using need to be water soluble? For example, if you are drawing designs with markers on top of a painting and then you paint over that with watercolor, the markers, if water soluble, may bleed into the rest of the painting when water is added in the next layer. If you don't want such bleed through, you will want to use water-resistant markers.

A few general rules and guidelines for working in mixed media and watercolor:

- Oil-based mediums should be applied after water-based mediums.
- Some mediums may require fixative, like dry pastels. This is especially true if the pastels will be a final layer.
- Mediums used in your first layers should be water-resistant if you want to paint over them without bleeding or mixing.
- You can apply workable fixative between layers while painting if you want to keep on working without disturbing the previous layers. Use fixative or spray varnish before brushing varnish onto your finished piece to avoid any smudges and to fix pastels and other dry media.
- Always use archival acid-free materials if longevity is a concern.
- Have fun and experiment!

These drawings added with markers and graphite on top of watercolor and acrylic will need to be covered with fixative before paint is added or the piece is varnished.

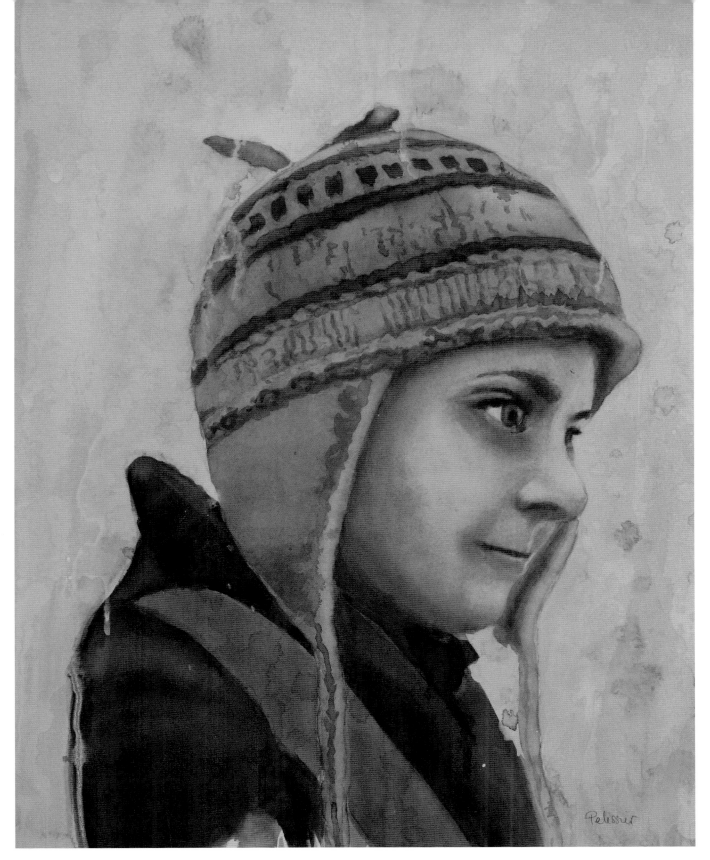

TALES OF A LUCKY HAT
Watercolor and mixed media on paper
26" × 15" (66cm × 38cm)
A few drips of gouache mixed with watercolor and water has been allowed to run from the
background onto the figure as a way to emphasize the painted nature of the portrait.

MIXING DRY OR OIL PASTELS WITH WATERCOLOR

Dry pastel and watercolor can work very well together since they are both very matte. Pastels can be a great way to modify a watercolor that's lost its impact: Add speckles of bright colors or pastel smudges for subtle effects. Oil pastels can also be used on top of watercolor. I like to add some touches or outlines of pastel color after the painting has been completed. Pastels will act as a resist if added before painting.

Dry Pastel on Top of Watercolor

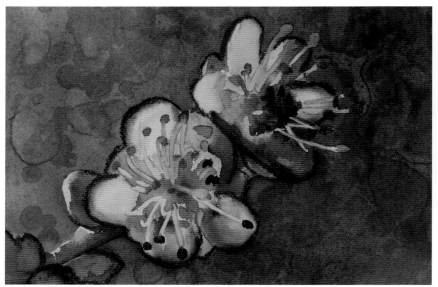

CHERRY BLOSSOMS
Watercolor and pastels on paper
9" × 13" (23cm × 33cm)
This painting was working well as a watercolor-only painting, but I felt it a bit too common and unoriginal for my taste. The brightly colored and textured pastel helped push it a bit further by accentuating the contrasts and giving it a bit more audacity and punch.

Dry or Oil Pastel Outline

An oil pastel outline has been added to the hair in *A Bird's-Eye View of Charlotte*. The pastel was added after the watercolor painting was finished. Colored pencil lines have also been added to the hair for texture, depth and contrast.

Do I Need to Fix the Pastel?

Oil pastel won't need to be sprayed with fixative but note that if you want to varnish your painting, you will need to use a varnish suitable for both water- and oil-based media.

Dry pastel will need to be fixed, especially if you are not going to frame your painting under glass. Spray fixative when the painting is dry. Note that the fixative spray will make the pastel colors appear a bit darker.

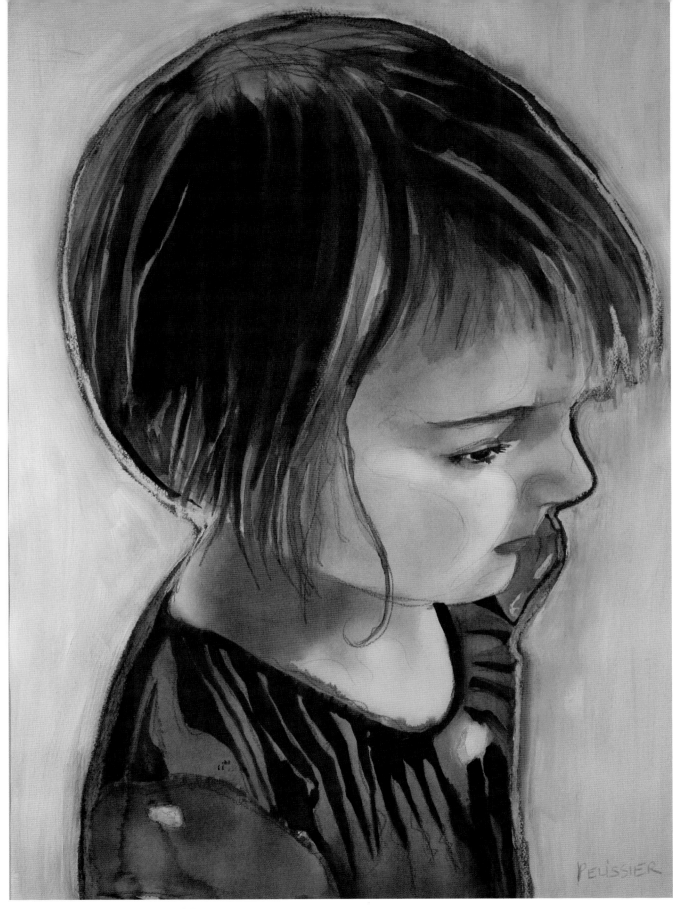

A BIRD'S-EYE VIEW OF CHARLOTTE
Watercolor and mixed media on paper
29" × 21" (74cm × 53cm)

ADDING GOUACHE TO A WATERCOLOR PAINTING

Gouache is very similar to watercolor, and it is a water-based paint. The main difference is that gouache is semi-opaque to opaque while watercolor is essentially transparent. Gouache dries a bit darker than it appears wet, and watercolor dries a bit lighter.

Gouache makes a great addition to a watercolor painting since it allows you to have transparent and opaque passages in your painting. You don't need to buy a whole set of gouache paints since you can mix your watercolor pigments with white gouache to make opaque colors.

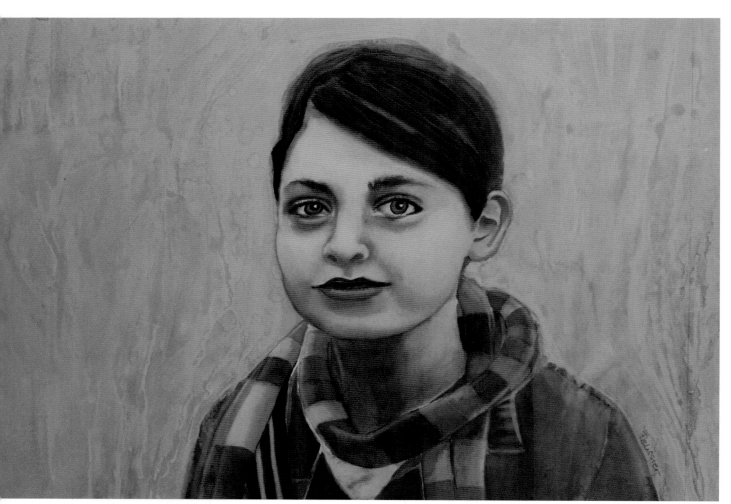

MULTI-COLOURED DAYS
Watercolor and mixed media on paper
18" × 22" (46cm × 56cm)

But What Exactly is Gouache?

Gouache is traditionally made from the same pigments watercolors are made from but with added gum Arabic and a white inert pigment that will make it reflective and opaque. That pigment is usually chalk. Gouache is water based and dries fast. It is opaque and highly pigmented, so unlike watercolors, you can paint a lighter color on top of a darker color. Gouache can be made water-resistant if you use an acrylic medium to mix it instead of water.

Painting a Background with Watercolor and Gouache

Adding gouache to watercolor portrait backgrounds is a technique you should try. The gouache will make abstract textures as it dries, and the opacity of the gouache will contrast nicely with the transparency of the skin tones in the portrait.

For this painting, I worked from a reference photo of my daughter. After stretching and drying your watercolor paper on foamcore, you can transfer a sketch using carbon or graphite paper.

1 Paint the First Layers
Your base layers should be painted mostly using a wet-on-wet technique so the face doesn't have any unnaturally hard edges. Start with your lightest colors. Be sure to preserve white areas (like the whites of the eyes) with masking fluid. I painted in layers, starting with yellow, then red, then blue.

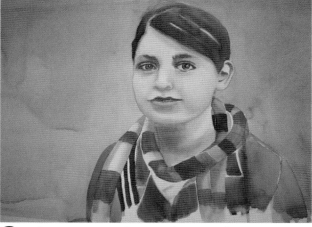

2 Paint a Watercolor Background Layer
Layer a few watercolors in the background; they will show through the gouache if the gouache is applied lightly. Doing this will produce a glowing effect.

3 Mix Gouache with Ink or Watercolor
Mix white gouache with ink or watercolor. For this painting, I used blue acrylic ink.

4 Paint Over the Background
Apply a layer of blue gouache and ink on top of the watercolor background layers in an irregular way—you want to give the background a complex texture with some colors showing through the light blue layer of gouache.

ADDING ACRYLIC PAINT

This is an interesting technique if you like the figures in your portraits to have an outline and textured background. Basically you are painting a first layer in the background, either with watercolor, ink or acrylic, and then you are painting a second layer on top leaving some of the first layer to show through either the edges or the texture of the background, or both.

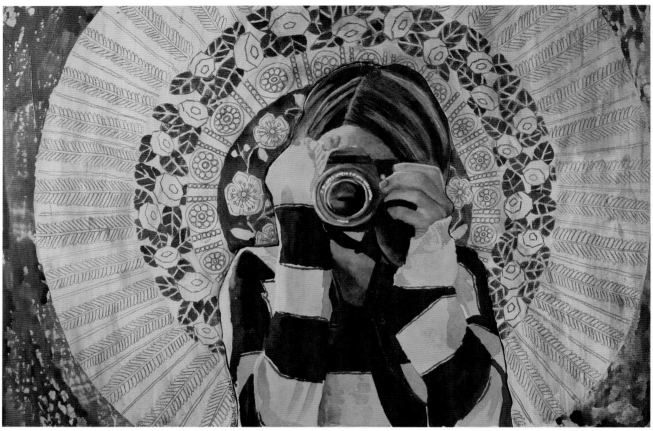

SELFIE
Watercolor and mixed media on paper
15" × 22" (38cm × 56cm)
You can leave the background of your portrait as it is or paint additional layers on top on your India ink and acrylic paint background. For my finished painting, I added watercolor paint and designs drawn with watercolor crayons.

What is the Difference Between India Ink, Black Watercolor and Black Acrylic?

- India ink is different from acrylic in that it is made of soot with a binding agent. Different kinds of India inks have different degrees of water resistance. In my experience most India inks are not totally water-resistant.

- When painted on paper and allowed to dry, the India ink will mix with the white acrylic painted on top, giving the ink irregular light gray accents. I guess that is because the ink is absorbed by the paper. If you want a lighter background, you can leave that first layer of acrylic to dry and it will fix the ink. Successive layers of white acrylic will lighten the background.

- Water resistance: India ink can be more or less water-resistant depending on the surface you are painting on and the type of ink you use. Acrylic-based inks and acrylics will be water-resistant once dry. Black watercolor won't be water-resistant and will actually lift quite easily.

- Lightfastness: Inks are made of dyes and acrylic paint, and watercolors are made of pigments. Pigments have better lightfastness than inks, although India ink has pretty good lightfastness; it is made of soot that is diluted in water with a binding agent.

- Fluidity: Inks and fluid acrylic will be liquid, while acrylic will generally have a bit of body to it.

Painting a Background with Acrylic and India Ink

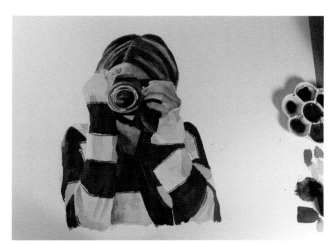

1 Paint a Simple Portrait
Paint a simple portrait with watercolor and leave the background unpainted.

2 Paint an Ink Background Layer
Carefully paint your first background layer using India ink. Pay extra attention to the edges—you don't want any white of the paper to show between the figure and the background, but you also don't want the ink to overlap the watercolor figure.

3 Mix Gouache with Ink or Watercolor
Once the ink is completely dry, paint over it with white acrylic. The acrylic is semi-opaque, so the resulting color will be a light gray with some variation because the ink will mix slightly with the acrylics.

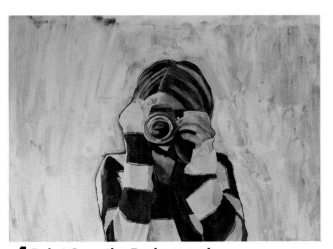

4 Paint Over the Background
If you like the effect, you can leave a small outline along the edges of the figure where the ink has not been painted over with acrylic.

Adding Colored Pencil

If, like me, you like the idea of mixing elements of drawing in your paintings, you might be interested in trying various techniques to incorporate designs and drawings into your watercolors. For this demonstration, I wanted a somewhat realistic rendering of flowers juxtaposed with a stylized rendering of flowers. I decided to add two stripes of patterned flowers in the background of the realistically painted flowers.

Colored pencils offer the advantage of being available in many colors. You can draw a line or color an area, and they won't smudge the way watercolor pencils do if you decide to paint on top (they act as a resist).

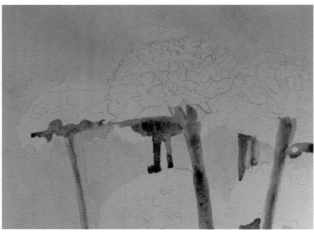

1 Draw and Then Paint a Simple Still Life
Draw your subject on the paper (I am working from a photo of green chrysanthemums). Paint a light, textured background first, then paint in the flower stems and leaves.

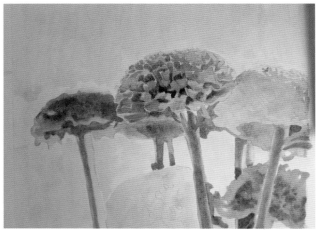

2 Paint the Flowers
Paint the flowers by layering several watercolor washes to build up the texture. Add layers to the background as well.

3 Mark Edges or Borders for Your Background Designs, If Desired
If your designs are not going to cover the entire background, you can draw in edges or borders before you begin. For example, I want my designs to be integrated as two stripes in the background, so I'm using a ruler to mark the edges of the stripes with graphite.

4 Draw in Designs with Colored Pencils
Draw in your designs with colored pencils. Keep your pencils well sharpened so the thickness of the lines in your designs is consistent.

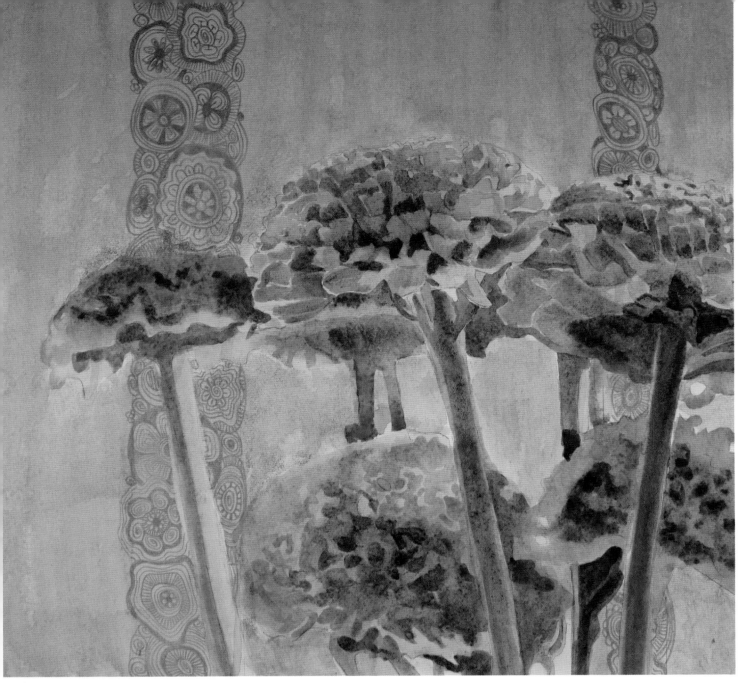

GREEN MUM
Watercolor and mixed media on paper
mounted on board, wax finish
16" × 16" (41cm × 41cm)

Where Can I Find Pattern Ideas?

Patterns are fun and exciting, and there are endless sources of inspirations: doodles, Zentangles®, flowers, fabrics, wallpaper, lace, crochet…

Make a Pinterest board, a folder on your computer or a collection of pictures where you can keep interesting patterns. Go through your collection when you need inspiration for a painting.

Drawing with Watercolor Pencils

Watercolor pencils dipped in water work as an alternative to brushing watercolor with a thin brush. This technique also results in darker, more pigmented lines than dry watercolor pencil does.

1 Dip Your Pencil in Water
Dip your pencil in water before drawing. The lead will soften if you use it for a while, so you might need to dry it and sharpen the tip regularly to ensure you get the line weight you want.

2 Draw on Top of Your Watercolor Painting
Draw the designs or patterns you desire on top of your watercolor painting.

Versatility of Watercolor Pencils

Watercolor pencils can be used in many ways in your watercolor paintings:

- When painting really fine details, like the number on a door, for example, you can try to draw that number with a pencil (dipped in water or not) instead of painting it.

- You can accentuate some areas on your painting by coloring lightly with dry watercolor pencils on top of the dry paint.

- You can add patterns as shown above.

- You can draw with dry watercolor pencils on some areas you want to smudge more before splashing water on a painting.

Remember that watercolor pencil will smudge if you paint over it. If you don't want this to happen, you can use colored pencils to draw patterns instead.

GEORGIA, THE SPANISH DRESS AND THE ECLECTUS PARROT
Watercolor and mixed media on paper
22" × 15" (56cm × 38cm)
The background designs and outlines were drawn with watercolor pencils dipped in water.

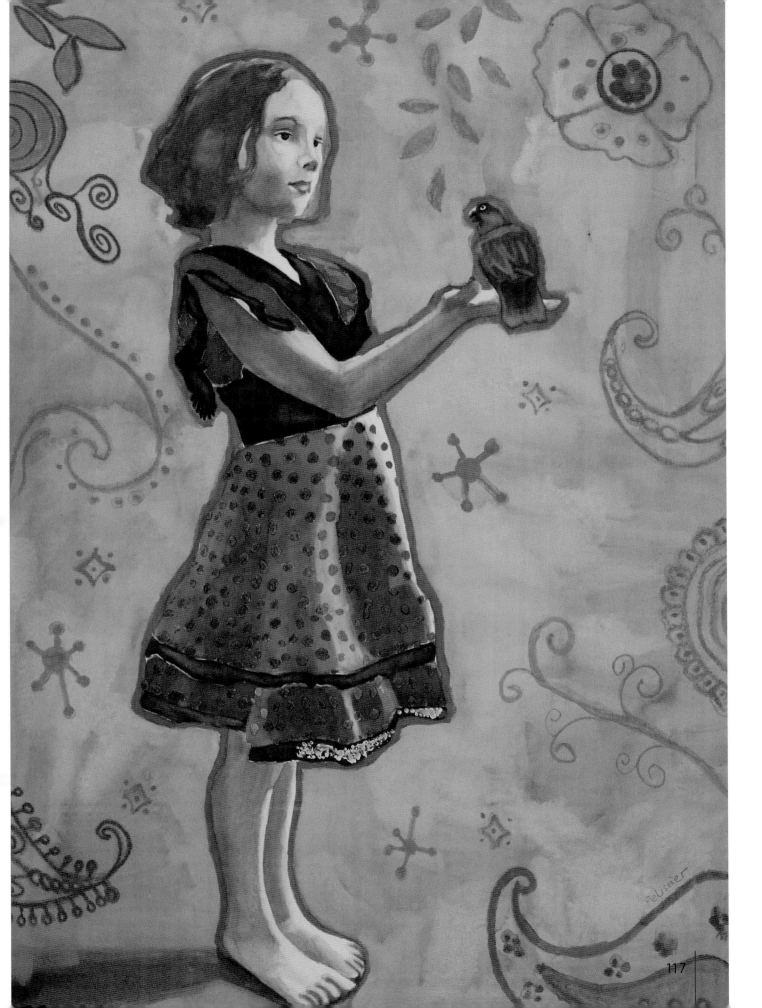

SEWING ON PAPER

Sewing on paper works really well and produces a crisp line that can be a valuable addition to your design. There are, however, two things to consider.

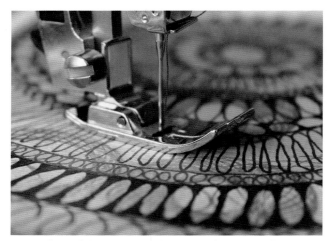

Sewing will create holes in your paper where paint might accumulate if you paint on top of the sewing.

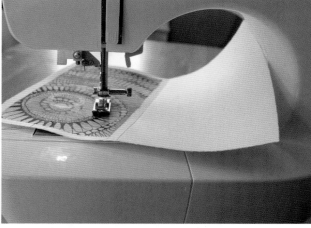

You are limited by the distance between the needle and the side of the machine, so take this into consideration when planning your painting. You can roll the paper if you want to access areas in the middle of a bigger sheet of paper, but you run the risk of making visible fold marks on the paper.

Examples of Sewing on Paper

These are postcard designs I did to show the sewing-on-paper process. I use this technique on smaller projects because of the limitation of the width of the sewing machine arm.

In these examples, the sewing was the last step because it makes holes in the paper, and the paint will accumulate in those holes if applied after the sewing.

The first example features a background painted with salt (added for texture). Then I drew the poppies with waterproof markers, and I added another darker layer on the background for contrast. The final step was the sewing.

The second features a layer of designs made with an hypotrochoid set (sort of like a Spirograph®). Then I added designs with markers before adding the stitching.

CLICK IT! To learn more about Sandrine's process for **Experimenting with Postcards**, visit PaintingDemos.com/experimenting-with-postcards.

CLICK IT! To learn more about Sandrine's process for **Experimenting with Hypotrochoid Designs**, visit PaintingDemos.com/experimenting-with-postcard-sized-watercolor-paper-alcohol-acetone-hypotrochoid-designs-and-patterns/.

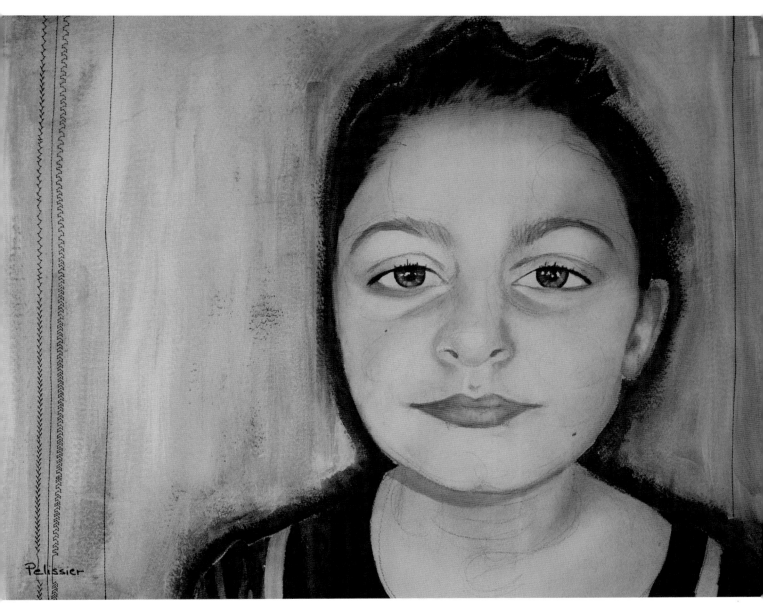

LOUISE
Watercolor, mixed media and sewing on paper
21" × 29" (53cm × 74cm)
This portrait was painted using layering technique shown in
Chapter 3, Painting with Multiple Color Mixing Techniques. Then
I painted a layer of black acrylic in the background, followed by a
layer of white acrylic that allowed some of the black underneath to
show through the paint and around the edges. The contours have
been accentuated with dry pastels.

ADDING ZENTANGLES WITH MARKERS

Zentangles® are repetitive drawings of structured patterns. I am doing my own version of tangling by adding repetitive symmetrical designs with markers to watercolor paintings.

For the beginner, markers are much easier to handle than pen and ink—there is always a risk of ink spilling from the pen. An ink spill on watercolor paper is very difficult to remove.

If you have a lot of experience with markers and enjoy it, I suggest you try pen and ink.

Try drawing geometric patterns into plants. In this example, I've drawn patterns into leaves and stems.

In this example, I'm adding a pattern to a tree trunk. Since my chosen pattern is detailed and very geometric, I drew a grid with graphite to use as a reference.

Do I Need to Fix the Marker Drawing and Can I Paint Over It?

Some markers are water-resistant and some markers are water-soluble. On a spare piece of paper you can paint over a design and see if the marker smudges or not. If the markers are not water-resistant you can spray fixative before painting or varnishing on top. The fixative will change the properties of the paper though, and make it more water-resistant. The paint applied afterwards, especially watercolor, will react as if it was painted on Yupo paper or gessoed paper.

You can also add designs as the last step of your painting process so you won't have to paint over the markers. The designs drawn in marker will need to be fixed if you want to brush varnish as a finish.

A LITTLE BIRDIE TOLD ME
Watercolor and mixed media on paper mounted on board
21" × 26" (53cm × 66cm)
I like my portraits to have a fairy-tale feel that mixes the realistic with the imaginary. In this painting, I am juxtaposing a more realistic portrait with abstract elements, like a monochrome tangled bird and suggested background. This portrait was painted using a layering technique shown in *Chapter 3, Painting with Multiple Color Mixing Techniques*. I wanted to keep the background painted in a simple way since I knew I wanted to add extra layers of patterns, so I painted a very light and simple wash that just outlined the tree shapes. I wanted the bird to stand out but not look realistic, so I painted it with just one color: Permanent Red (Holbein) with added splatters. Next I looked in my Zentangle® books and online for patterns that would fit the painting. I did not make them up, except for the part that follows the plant shape on the left of the figure. I wanted the patterns to be present but not to overpower the whole picture, so I only covered part of the background with patterns. Since I wanted the bird to stand out as much as possible, I chose a darker and finer marker and more intricate details for its patterning.

DRAWING ON TOP OF A PORTRAIT WITH WATERCOLOR PENCILS

Mixing drawing and painting can lead to very intriguing results. What I like about this technique is that the drawn lines are usually not very visible from a distance but will show upon closer inspection of the painting. They provide more levels of complexity.

DAY OFF
Watercolor and mixed media on paper
29" × 22" (74cm × 56cm)

In this close-up of *Day Off*, lines have been drawn on top of the portrait, many that detail or highlight the creases in the shirt.

You can also draw patterns with watercolor pencils or crayons. This example is from the painting *Selfie* (see *Chapter 5, Adding Acrylic Paint*). Drawing doodles on top of an acrylic or ink layer is a great way to add special details.

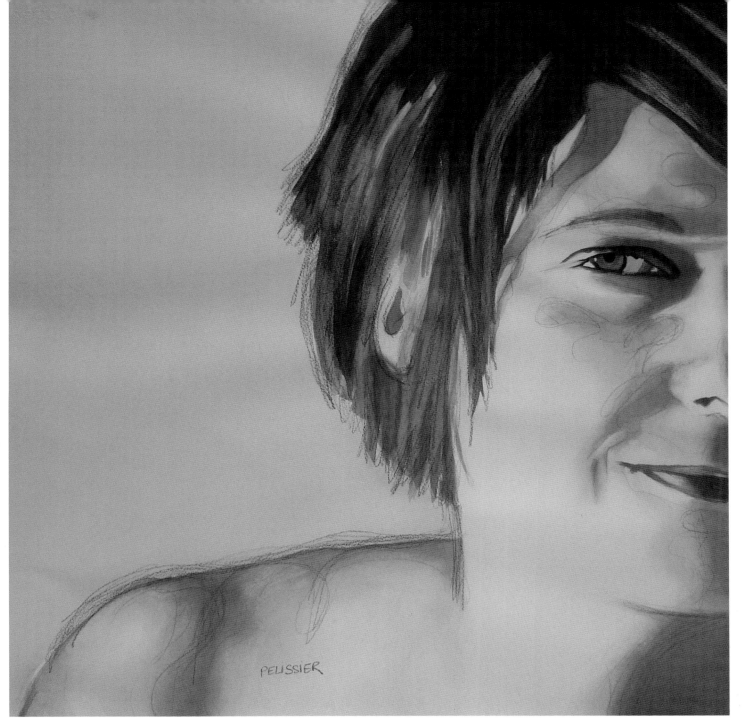

PELISSIER

SELF PORTRAIT
Watercolor and mixed media on paper
20" × 20" (51cm × 51cm)
Private collection
(From a photo by photographer Paula Vander)
This portrait is painted from a reference picture that my friend Paula took. The reference picture already had the unusual cropping that I liked but I wanted more than just a realistic rendering of the picture. So, once the painting had time to dry, I started adding colored pencil marks that are reminiscent of the ones I would make if I was doing a quick sketch for that portrait without being too careful. I like the combination of carefully planned slow painting and spontaneous, fast gesture drawing.

I did a drawing from the reference picture that I transferred onto the watercolor paper. The portrait and the background are carefully painted by layering colors to render the skin tones using a technique demonstrated in *Chapter 3, Painting with Multiple Color Mixing Techniques*. I used masking fluid only for the white of the eye.

Combining Painting and Drawing

You previously saw examples of lines drawn on top of a watercolor painting and of patterns added with drawing media. You can also draw one part of a painting and paint the rest. For example, on a portrait you can paint the face and draw the hands or some element of the clothing, like a scarf. In this demonstration, you will draw the hands.

1 Layer Watercolors and Paint Background with Gouache

Paint your portrait as you normally would: Layer your watercolors and work from light to dark. Once the watercolors are dry, add a layer of white gouache to your subject's background. Let the paint dry completely.

2 Paint the Hand and Draw in Details

Paint the hand with a very light wash of Alizarin Crimson. After the paint has dried, draw in the details of the hand with a red watercolor pencil.

3 Draw Textural Lines in the Background

Draw lines with your colored pencil over the gouache background to add texture and contrasting color.

4 Draw in Designs with a Watercolor Pencil

Use a watercolor pencil dipped in water to draw henna designs onto the hand and arm.

NOW YOU SEE ME
Watercolor and mixed media on paper
20" × 24" (51cm × 61cm)
The background was first painted with watercolors. Then I added a layer of gouache and then the lines with colored pencil.

The inspiration for the patterns on the hand are traditional henna designs. I found that brown watercolor crayon dipped in water looked very much like henna.

After painting over the background with watercolor and gouache, I felt the overall painting lacked contrast in color temperature; in other words, the painting was too pink. I added the textural green lines to the background to balance the pink.

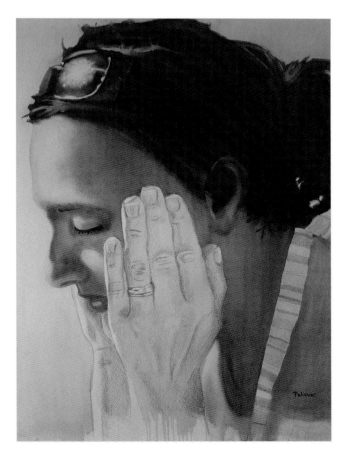

MIXED
Watercolor and mixed media on paper
29" × 22" (74cm × 56cm)
For this painting, I wanted the hands to have the feeling of a classical drawing. I painted a very light wash before drawing the hands in a classical style and with crosshatching shading.

The bit around her neck is the strap of a swimsuit. It helps to balance the composition by adding a drawn element to the right side of the painting. The direction of the strap is vertical, which works well with the placement of the hands.

I scrubbed off quite a bit of paint with a stiff brush and water to lighten areas in the hair and in the shaded areas of the face.

Drawing with Watercolor Pencils and Pastels

When painting, you can easily become lost in details and find it difficult to paint in a looser, softer way. This technique allows the "precise" painter to give up some control by allowing the water to move the paint in unpredictable ways. The successive layers of pastels and watercolor allow for added definition within a ghost image.

1 Outline Your Design
Draw the outline of your design with graphite on paper.

2 Color the Design with Watercolor Pencils
Color the different sections with dry watercolor pencil. Remember, you can layer different colors to make color mixes.

3 Spray the Drawing with Water
Spray your drawing with water and let the colors move freely. Allow the paper and the pigments to dry.

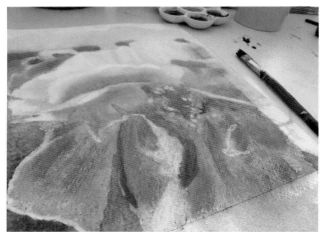

4 Define and Finish with Pastels
Refine your image by using whatever medium you like: washes of watercolor, more watercolor pencil, acrylics or pastels. Pastels are convenient as they allow you to paint light on dark and retrieve some light in your painting—something you can't do with watercolor.

CLICK IT! For tips on loosening up, visit **ArtistsNetwork.com/fearless-watercolor**.

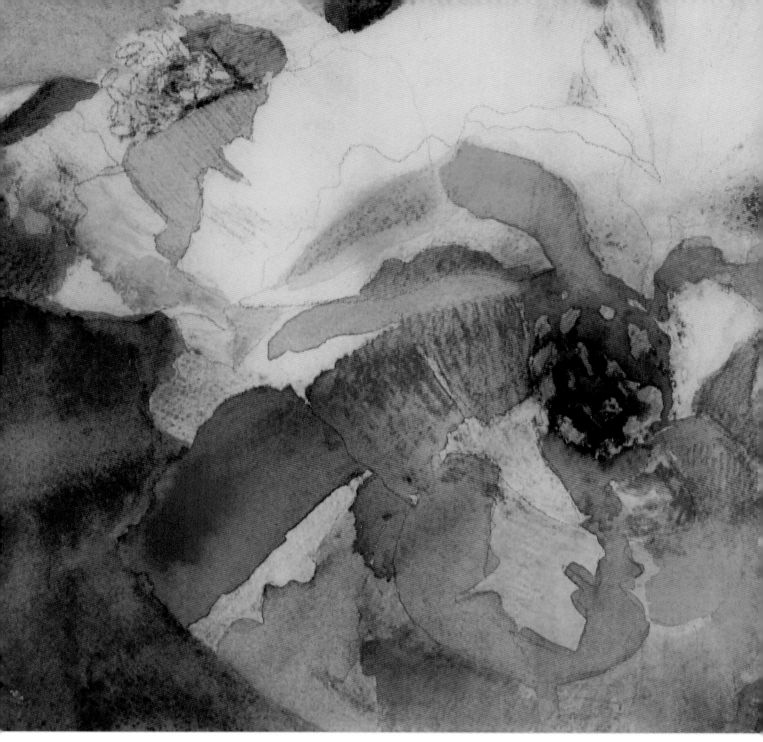

PEONY
Mixed media on paper mounted on canvas
12" × 12" (30cm × 30cm)
This painting features a lot of mixed-media techniques:

- The peonies were first painted on paper using the technique shown on the previous page. I like that you can still clearly see the line of the original drawing in graphite and also some of the lines of watercolor pencil that were not totally mixed when I sprayed the image with water.

- When sprayed with water, the image became very blurry. I call it a ghost image. The peonies were mostly redefined with watercolor washes (wet on dry) once the paper had time to dry and a touch of dry pastel here and there.

- The paper was then mounted on canvas using gel medium.

- I added a final layer of resin for an extra-shiny finish.

MIXED MEDIA ON YUPO PAPER

Yupo paper is a synthetic water-resistant paper made of 100 percent polypropylene. When Yupo is painted over with watercolor, your paint will dry only by evaporation and there will be no absorption by the paper (as there would be with regular watercolor paper). This is why Yupo paper allows very nice textures to form while the paint is drying. This is also why the paint will take a longer time to dry.

What Media Can I Use on Yupo Paper?

Pencil on Yupo Paper
Pencil works great on Yupo paper. It makes a very crisp and clean line. But it's a little difficult to erase completely and prone to smudging.

Watercolor on Yupo Paper
Watercolor works very well for painting on Yupo paper and can be lifted easily if needed.

Markers on Yupo Paper
Markers slide very nicely across toothless Yupo. Depending on the marker, it may smudge once it's dry. Markers will definitely smudge on Yupo while wet, so use caution.

Acrylics on Yupo Paper
Fluid acrylics and acrylics with more body can both be used on Yupo paper. Fluid acrylics will behave somewhat like watercolor paint. The main difference is that acrylics won't lift off the paper as easily, thus allowing layering techniques that are more difficult to execute with watercolors. Acrylics with more body will work well also.

What is the Difference Between Yupo Paper and Regular Watercolor Paper?

Because paint dries only by evaporation on Yupo paper and because Yupo paper doesn't have any tooth at all, textures occur very easily. It is difficult to paint a flat wash on Yupo paper. When painting wet on wet the colors are moving and mixing really fast, making the final result more difficult to control.

Paint on Yupo paper can be lifted with a wet tissue, and if you are using nonstaining pigments you will easily renew the white of the paper in any area you would like to rework.

To paint dark areas on your painting, you can use the following technique: Use watercolor paint either directly from the tube or very slightly diluted. It will be easy to manage, and you will get a darker color. Then use a clean tissue on the still-wet area you just painted to lift the paint carefully. Doing so will add some transparency to the dark areas you paint.

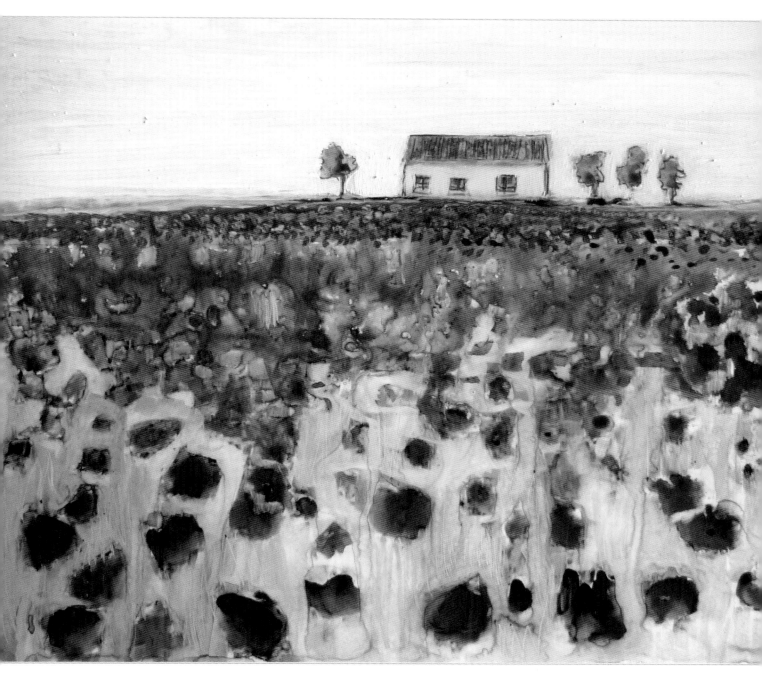

POPPY FIELDS
Watercolor, pastels and gouache on Yupo paper
8½" × 11½" (22cm × 29cm)
For this painting, I did an initial drawing with graphite and then painted the whole picture with watercolor. I added acrylic in some places (such as the sky) and touches of pastel. I painted over some of the pastel with water (pastel brushed with water behaves much like gouache). I scratched off some of the wet paint between the poppy flowers in the field as a way to create grass and stems.

COLLAGE ON YUPO PAPER

Yupo paper is not only for watercolor; you can mix media on this surface for interesting effects. The most challenging characteristic of Yupo is the absence of any tooth or texture, which makes it difficult for some mediums, such as chalk pastel, to adhere. The absence of tooth also makes it a very pleasant surface to work on with graphite or oil pastels.

Collage on Yupo
Collage with acrylics will work well on Yupo paper. I especially like the textures made with tissue paper, as the color underneath the tissue will show. This technique allows you to use dry pastels more easily because your collaged areas will have more tooth than the Yupo paper.

Chalk Pastels on Yupo
It is possible to use chalk pastels on Yupo, but they won't adhere well due to the lack of tooth of the paper. If you are using pastels, fix them with workable fixative when you are done.

Oil Pastels on Yupo
Oil pastels will present a better adhesion than chalk pastels. Layering is still very difficult, but sgraffito is very easy and can produce interesting effects. You can use oil pastels as a resist that limits some painting areas. It will prevent watercolor from going in every direction, giving you more control of the paint.

India Ink on Yupo
India ink will produce a very strong contrasting black on the bright white of Yupo paper. You can dilute it to obtain different shades of gray, then work it the way you would other inks, watercolors or liquid acrylics on Yupo paper. The ink will stain the paper, and once it dries it is very difficult to lift.

CLICK IT! To learn more about the making of *Autoportrait 5*, visit **PaintingDemos.com/ autoportrait-5-an-experiment-in-ink-wash**.

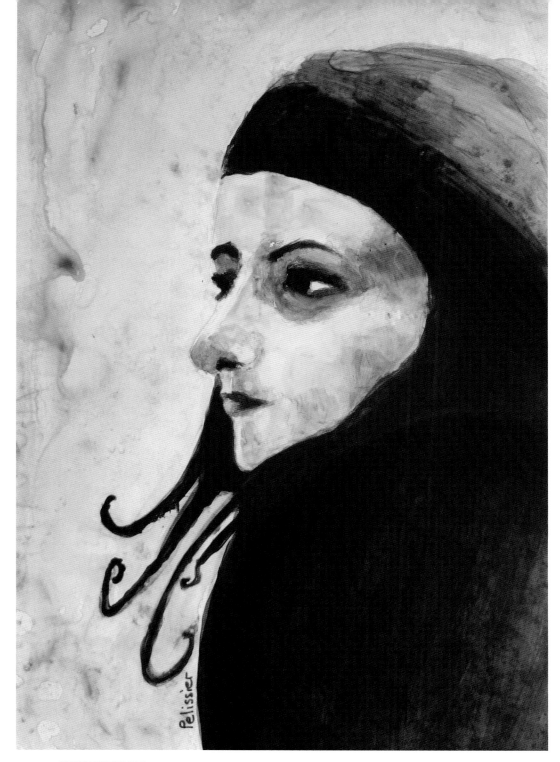

AUTOPORTRAIT 5
Fluid acrylic and mixed media on Yupo paper
14" × 11" (36cm × 28cm)
This portrait was painted using a gouache-resist technique: Gouache is painted over the areas you want to keep light. Then a layer of India ink is applied to the whole painting and allowed to dry. Then the painting is rinsed with water in the sink. The gouache acts as a resist and prevents the ink from staining the Yupo in the areas where gouache has been painted. You end up with a ghost image you can rework with whatever medium you wish. I used fluid acrylics, but I could have used watercolor. I layered the fluid acrylic the same way I would layer watercolor to build up a portrait: by painting successive layers of yellow, red and blue.

This technique is interesting because you can't be too precise. The process of painting the white areas, applying ink and rinsing results in an imperfect image with stains and a kind of aged, somewhat childish look. That is part of the charm of this technique.

Collage on Yupo

Collaging paper on Yupo is a technique you can try if you want to add a bit of tooth and texture to your painting.

1 Collage Tissue Paper to Your Painting
Brush thin tissue paper onto your painting with gel medium. Don't worry about adding wrinkles and creases—these add visual interest, depth and tooth.

2 Add Other Media as Desired
Once the gel medium has dried, integrate media such as dry pastels. The tooth provided by the gel medium and the tissue paper will result in the firmer adhesion of additional media.

ABSTRACTED LANDSCAPE
Mixed media on Yupo paper
9" × 9" (23cm × 23cm)
I find that working with horizontal layers of color and texture works well in creating a semi-abstract representation of an imaginary landscape. Collaging tissue paper on Yupo produces fine wrinkles that are reminiscent of natural textures found in stones or rocks. The textures naturally formed by watercolor drying on Yupo add interest to the landscape, while pastels allow for soft atmospheric changes of color near the horizon line. It could also be used for bright accents of vivid color here and there. In this example, I used contrasting red watercolor in the green stripe of the trees for accents of contrasting colors.

SOMEWHERE 8
Mixed media on Yupo (watercolor, collage, pastel)
8" × 13" (20cm × 33cm)

This mixed-media piece has been painted with watercolor. To add a bit of interest I tore some pieces of tissue paper so they had interesting irregular contours and fixed them with gel medium on top of the watercolor washes. I spread that gel medium all over the painting, on top of the watercolor-painted areas so I could add another layer of watercolor on top.

It is very difficult to work with layers of watercolor on Yupo paper because the brush can easily disrupt the previous layer. Fixing the first layers of watercolor with gel medium allowed me to paint another layer of watercolor on top of that first layer. Collaging the tissue paper provided some tooth, and I was able to use chalk pastels for some contrasting contouring where the tissue paper had been collaged.

Do I Need to Use a Fixative on Yupo?

It depends on whether you want to frame your painting or mount it on a board. If the painting is framed, you might not need to fix it, although it can be a good idea to do so to avoid any problems before framing. Workable fixative is a good product to use in between layers; spray varnish can be used at the end.

I recommend fixing anything that involves dry pastels, as they can lift very easily.

Note that if you used water-based media as well as oil-based media, you need to use a varnish that is suitable for both.

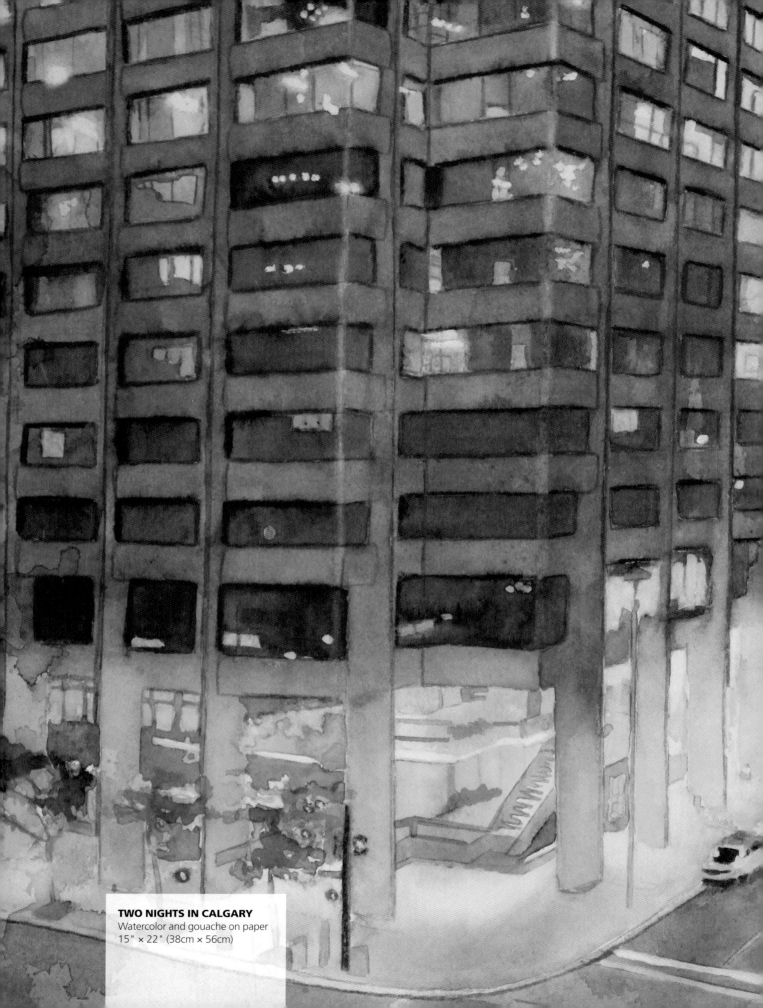

TWO NIGHTS IN CALGARY
Watercolor and gouache on paper
15" × 22" (38cm × 56cm)

A Few Last Thoughts

BE YOUR OWN CRITIC

While it is not easy to gain perspective on our own work, here is a list of elements you might want to check in both the earlier stages of planning and in the last stages.

Of course, depending on the effect and the look you would like to achieve, rules can be broken; this list is just a rough guideline of elements you might want to consider when assessing your work. And it always looks better when a rule is broken intentionally rather than by mistake.

Assessing Your Own Work

When working on a painting or a drawing, we can get so involved in the process that we can't clearly or objectively judge what we are making. We might be too critical of something that looks good or we might miss an obvious problem. The fact is that when you look too long at something, you don't really see it anymore, and when you get involved in details, it becomes difficult to see the whole.

Here are a few strategies I've used over the years to gain a new perspective when working on a painting or a drawing. Each allows me to see what I am working on with fresh eyes.

Time

Not the most convenient strategy I must admit, but quite effective. It might have happened to you: You found an old painting that you were ready to throw away just after finishing it, and you see it now, a few months or years later, and you realize it's not bad at all. When working on a piece, we tend to focus on the struggles and might notice only the little details we dislike. Someone looking at the same painting for the first time might not see those problems. Sometimes taking a short break from the painting or drawing can help you see it with fresh eyes.

Distance

Looking at your work from a distance can be helpful. You can also take a picture of the work in progress and look at it either on the screen of the camera or on your computer. I find that looking at my painting as a thumbnail helps a lot with composition and assessing what works well and what doesn't.

Viewing Your Work as a Thumbnail
Viewing your work in thumbnail size or from a distance provides a new perspective.

Mirror Image

This is a very useful trick; you can either hold the painting up to a mirror or take a picture and make a mirror image on your computer. This is particularly effective for evaluating composition problems and for painting portraits.

Seeing your picture in a mirror image gives you a fresh perspective.

Element of Surprise

Placing the painting or drawing in an area of your house where you might see it inadvertently can also be helpful.

Computer

Working on your computer can be helpful for more than mirror images, grayscale and composition. If you are familiar with your photo editing software, you can create variations of your painting to see what direction you might go with it. You can play with adjusting the brightness or contrast, vibrancy, color balance and hues. Or you can add textures.

Grayscale

Looking at a grayscale version of your image will help you determine if you have enough tonal variety and contrast. I take a picture and make a grayscale version of it on my computer. You might not want a high contrast for all your paintings. Less contrast creates a softer image.

Grayscale of Hornby Street
A grayscale image allows you to easily see the contrast in your picture. Here the contrast is higher in the foreground and fades in the background. (See *Chapter 6, Criteria for Evaluation* to see the finished, color version of *Hornby Street*.)

On the Subject of Grayscale

In my opinion, a master of tonal variety is Jean-Auguste-Dominique Ingres (1780–1867). A grayscale version of his painting *Le Bain Turc* (*The Turkish Bath*, grayscale version; source: Wikimedia Commons) shows an amazing array of subtle tonalities from black to white. Notice the light directed at the main character's head and shoulders, making her the focal point even though we see her only from the back.

CRITERIA FOR EVALUATION

Here is a list of criteria you can use to evaluate your own work. Again, you can choose to ignore some rules if you do so intentionally.

General Criteria

- Is there unity in the painting, or is there an element that is sticking out too much? Or is there an element outside the focal point that is too distracting or taking the viewer's eye away from it?
- Does the painting have enough contrast?
- Does the painting have a variety of textures?
- Do the colors work together?
- Are the positive and negative shapes interesting?
- Is there a focal point? Does it have more contrast, more details or brighter colors than the rest of the painting? Does the location of the focal point follow the rule of thirds? (Usually the focal point is situated around the one-third to two-thirds area of the painting either horizontally or vertically).
- Does the painting trigger an emotional response from you? Do you feel a connection to the subject?
- Does the painting convey a feeling or a specific mood?
- Is there something I do better or in a unique way in this painting? Is there something original? What is special about this painting?
- Is there some 3D effect, some depth?
- Is there a background and a foreground? Is the background receding in the distance?

HORNBY STREET
Watercolor on paper
15" × 22"
(38cm × 56cm)

Criteria Specific to Watercolor

- Do I have a variety of edges (soft edges and hard edges)?
- Does the painting demonstrate a variety of washes and techniques, wet-on-wet, dry-on-wet, dry brush?
- Are my dark areas bright and not muddy?
- Do I have transparent and opaque passages?
- Does it look like I have some control over the watercolor medium while also letting the paint do some things on its own?

FINISHING

Finishing is a personal choice. Personally I frame some of my paintings in a traditional way, and some I don't frame at all.

The paintings I display unframed have been mounted on board and have been finished to make them waterproof, either with a wax finish or varnish.

You can mount watercolor paper on board either before or after you have painted. Apply a thick layer of heavy-body gel medium to the board and then lay the paper on the board. Use a brayer to remove any bubbles or irregularities.

If you mount the paper before painting, you can wet it so it stretches at the same time. The advantage of this method is that you will paint on a hard surface, and the paper won't buckle at all. The disadvantage is that you might waste the board if you are not happy with the painting, though you should be able to sand the paper off the board once it dries.

If you mount the paper after the painting has been finished, you don't need to wet the paper.

The corners are a tricky area when mounting watercolor paper on a board. Make sure you have applied the medium all the way to the edges and the corners. Use paperweights to prevent the corners from lifting when drying.

Wax or varnish will make the painting water-resistant. The main difference between them is that varnish will contain UV protectors that are not present in the wax. Wax is easier to apply as you spread it on the painting with a soft cloth, and it smells really good. I like the natural look of wax on landscape paintings.

Varnish can be applied with a brush or as a spray. I recommend that you spray the first layer to avoid moving the paint with a brush.

Sealing with Wax

Sealing with Wax
Wax is applied with a soft cloth. It can be buffed to a gloss finish after drying for one day or so. (In this example I am using Dorland's Wax Medium.)

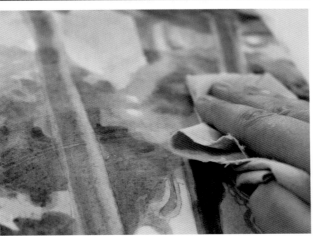

Sealing with Varnish

Sealing with Varnish

I recommend spraying the first layer of varnish to avoid disrupting the paint with your brush.

Mounting with Gel Medium

Mounting with Gel Medium

Apply a thick layer of gel medium to the board. Lay the paper on the board and remove any bubbles or irregularities with a brayer. Leave the painting to dry with paperweights on the corners. When the gel has dried, trim the edges of the paper.

INDEX

About Sandrine Pelissier

Sandrine Pelissier has been living in North Vancouver, Canada, for the last fifteen years. She teaches workshops in her North Vancouver studio and via several Vancouver-area arts associations.

Sandrine is an adventurous artist who enjoys experimenting with various media and techniques. She is inspired by exciting patterns in both nature and cityscapes and has a fascination for people and faces. Although her art could be described as somewhat realistic, it often offers a bit of abstraction or a part left to chance or fantasy.

She is an associate member of the Federation of Canadian Artists and has had paintings exhibited in numerous juried exhibitions in Canada and in the United States. Sandrine has been featured in *Watercolor Artist* magazine, *The Artist's Magazine* and *International Artist* magazine, and has been published in several books including the *Splash* series: *Splash 11*, *Splash 12*, *Splash 13*, *Splash 15, Watermedia Best of Worldwide*, *Incite 1* and *Incite 2*, and *Art Buzz 2009* and *2010*.

Learn more about Sandrine and her art:

PaintingDemos.com
YouTube: PaintingDemos
WatercolorPainting.ca

Dedication

I think it takes courage to be an artist and to express yourself by any art practice, because you are showing a personal part of yourself to the world and exposing yourself to criticism and praise. I would like to dedicate this book to all the artists who are taking risks in sharing their creations and living a creative life.

Acknowledgments

I would like to thank my family. Writing a book takes a lot of time and energy, and they gave me the opportunity to work on my project even though this meant a bit of chaos in our everyday life.

I would also like to thank my editor, Kristy Conlin, who was very supportive and helpful during the year it took to finish this project.

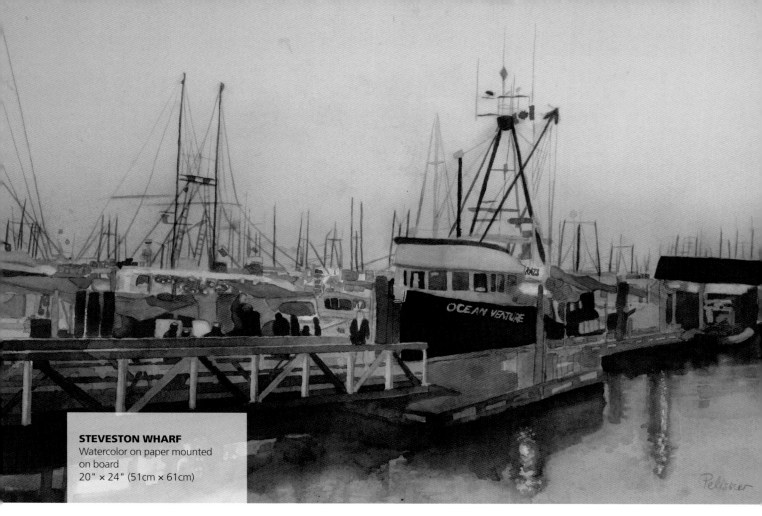

STEVESTON WHARF
Watercolor on paper mounted on board
20" × 24" (51cm × 61cm)

a content + ecommerce company

Other fine North Light Books are available from your favorite bookstore, art supply store or online supplier. Visit our website at fwcommunity.com.

19 18 17 16 15 5 4 3 2 1

DISTRIBUTED IN CANADA BY FRASER DIRECT
100 Armstrong Avenue
Georgetown, ON, Canada L7G 5S4
Tel: (905) 877-4411

DISTRIBUTED IN THE U.K. AND EUROPE
BY F&W MEDIA INTERNATIONAL, LTD
Brunel House, Forde Close, Newton Abbot, TQ12 4PU, UK
Tel: (+44) 1626 323200, Fax: (+44) 1626 323319
Email: enquiries@fwmedia.com

DISTRIBUTED IN AUSTRALIA BY CAPRICORN LINK
P.O. Box 704, S. Windsor NSW, 2756 Australia
Tel: (02) 4560-1600; Fax: (02) 4577 5288
Email: books@capricornlink.com.au

ISBN 13: 978-1-4403-3726-0

Edited by **Kristy Conlin**
Designed by **Geoff Raker**
Production coordinated by **Mark Griffin**

Metric Conversion Chart

To convert	to	multiply by
Inches	Centimeters	2.54
Centimeters	Inches	0.4
Feet	Centimeters	30.5
Centimeters	Feet	0.03
Yards	Meters	0.9
Meters	Yards	1.1